PETERSFIELD

THROUGH TIME

David Jeffery

AMBERLEY PUBLISHING

First published 2013

Amberley Publishing
The Hill, Stroud, Gloucestershire, GL5 4EP
www.amberley-books.com

Copyright © David Jeffery, 2013

The right of David Jeffery to be identified as the
Author of this work has been asserted in accordance with
the Copyrights, Designs and Patents Act 1988.

ISBN 978 1 4456 0857 0

British Library Cataloguing in Publication Data.
A catalogue record for this book is available from the
British Library.

Typesetting by Amberley Publishing.
Printed in Great Britain.

Introduction

Although the earliest traces of human settlement on Petersfield Heath date back to 6000 BC, and the twenty-one early Bronze Age barrows indicate a substantial settlement here, the town proper dates from the twelfth century, when it formed part of the large royal estate of Mapledurham, centred on the nearby village of Buriton. Henry I's son Robert, Earl of Gloucester, founded a borough in its northern part, where there was a small chapel dedicated to St Peter, a market place, and 'burgage' plots set out on either side of the main street to provide housing and space for a workshop or garden. The chapel was enlarged and the town received its charter in around 1170.

College Street has one medieval house left, and there are several Wealden-style houses in The Spain, Sheep Street and the Square. Three precious medieval treasures still exist: the silver-gilt town mace, dating from 1596; a Stuart coat of arms (now in the town museum); and the letters patent granted by Queen Elizabeth to Thomas Hanbury (now in the Winchester Record Office).

In the seventeenth century, the botanist John Goodyer, resident in The Spain, and his great-nephew, the horticulturalist John Worlidge, living in Dragon Street, both achieved national fame. Petersfield was hardly touched by the Civil War, although troops from both sides passed through the town. In the later seventeenth century, road travel increased, and mail coaches and stagecoaches stopped overnight on their way to and from London and Portsmouth, thus bringing prosperity to a new range of inns, including the Red Lion, still standing in Dragon Street.

Farming and hop-growing remained the chief industries in the eighteenth century, and the town boasted several brewhouses. Churcher's College, founded in College Street in 1729 by Richard Churcher, provided tuition for twelve local boys to become apprentices in the East India Company. The statue of William III in the Square was donated to the town by Sir William Jolliffe, who saw him as a symbol of liberty and Protestantism. William III succeeded the Catholic James II in 1689.

The Heath Pond was dug out by farmers in the mid-eighteenth century because they were losing their cattle in what was then a swamp. Petersfield's police station, designed by Thomas Stopher in 1858, is one of only two in Hampshire still serving the community since the Victorian era. Petersfield also had its own magistrates' court, which now houses the town museum. The arrival of the railway in 1859 transformed the town: it provided a direct link to London and Portsmouth, brought new commerce and housing, and led to a rise in the population to around 3,000.

Building expansion in the Victorian era included the corn exchange, the new board schools, the magistrates' courthouse, three new churches and a cottage hospital. St Peter's parish church was transformed by Sir Arthur Blomfield, Churcher's College moved to Ramshill, and Lavant Street became first residential and then commercialised. In 1898, the Square lost three of the historic buildings that had stood in front of the church and another, Castle House, was demolished in 1914. The Jolliffe family finally left the town in 1911, after five generations had served as the borough's MPs.

In the First World War, over 100 Petersfield men were killed, including Commander Loftus William Jones, who was awarded Petersfield's first VC for his actions at the Battle of Jutland. Between the wars, the town grew prosperous and new housing estates were constructed, as were a cinema, the war memorial and a new town hall. In the Second World War, just one bomb fell on the town, killing eight elderly men in the old workhouse. Hundreds of schoolchildren were evacuated here from London and Portsmouth, and thousands of troops passed through the town during the war and in preparation for D-Day in 1944.

The 1960s saw much demolition and the end of the cattle market, but the Herne Farm estate brought in several thousand new residents and a light industrial estate was created on the outskirts of the town. In the early 1990s, Petersfield obtained its bypass, the Taro sports centre and the Rams Walk shopping mall. Its population stands at around 15,000 today.

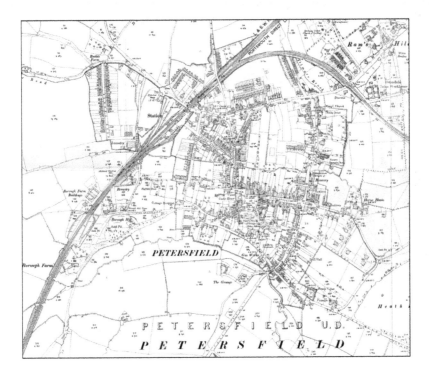

Petersfield Town Map, 1908

Between 1908 and 2008, the dates of these two maps, Petersfield developed extensively, of course, but particularly to the west of the railway. Apart from Rushes Road and Penns Road, built at the turn of the twentieth century, only farmland and fields used to exist to the west of the town. A hundred years later, with the A3 bypass completed – now almost an unofficial town limit – Petersfield is firmly embedded in the new South Downs National Park. Despite the enormous growth (the population has quadrupled in the past century), it is still a relatively compact town, clustered around its medieval heart: St Peter's parish church, the Market Square and the High Street.

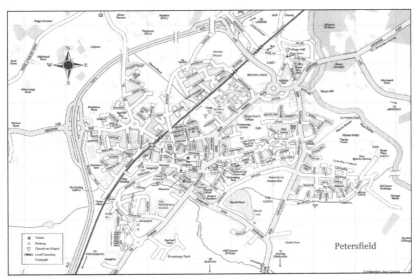

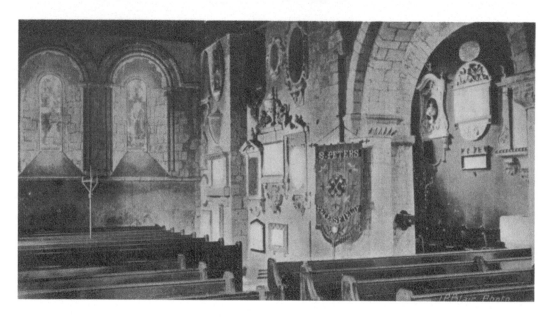

St Peter's Church, 1837

The interior of the twelfth-century St Peter's church underwent two restorations in Victorian times: the first in 1842 and the second by the celebrated church architect Sir Arthur Blomfield in 1873. The latter brought light into the darkness by the addition of a clerestory, thereby raising the roof and supporting it with some impressive timber trusses. The St Peter's 2000 Project brought a further transformation and more light by the installation of outside floodlighting, the laying of a Portland stone paved floor, and the removal of the old pews and their replacement with light wood chairs, while Sussex oak screens at the west end enclosed a new Lady chapel below the tower.

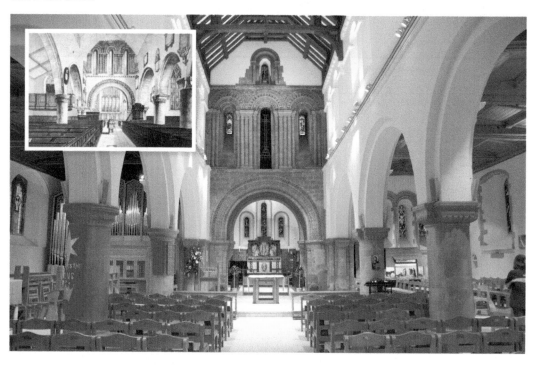

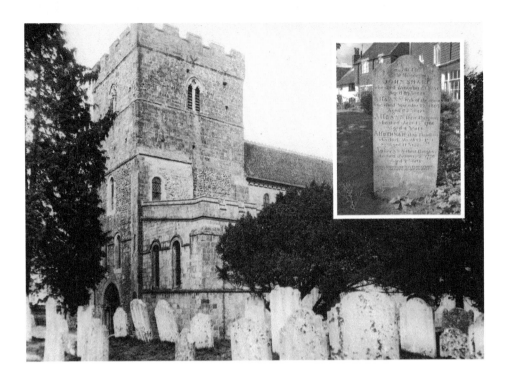

St Peter's Churchyard, c. 1890

This is the earliest known photograph of St Peter's churchyard, which had already been closed to burials in 1856. The ground was levelled and the tombstones re-erected around the perimeter in 1950, except for that of John Small (*inset*), the best batsman of the Hambledon Cricket Club – and, indeed, in all England – in the late eighteenth century. In Victorian times, burials took place at the town cemetery in Ramshill, where two chapels – still standing – were used for religious services. This is where all burials are now accommodated, although a small area behind the church is reserved for the interment of ashes after cremation.

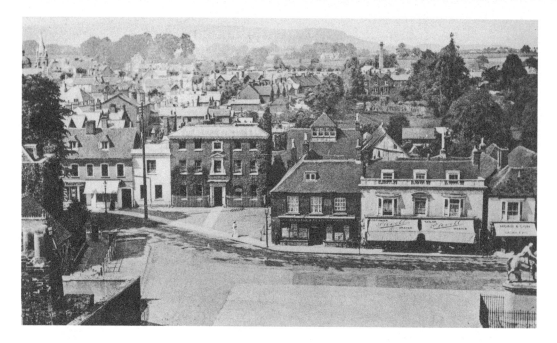

The Market Square, *c.* 1900

The Market Square dates from the foundation of Petersfield by Robert, Earl of Gloucester, in the early twelfth century. The town was granted a charter by Robert's son William, giving it a status equal in rights to that of Winchester. Petersfield is one of only a few towns in the south of England to still hold markets on their original sites, although cattle have not been sold here since 1963. The Square has always been the focus of open-air church services, military parades or the announcement of election results, but these have recently been supplemented by events such as a Victorian Day and festivals at Easter, August Bank Holiday (*below*) and Christmas, when music, dancing and dining take place around the statue of William III.

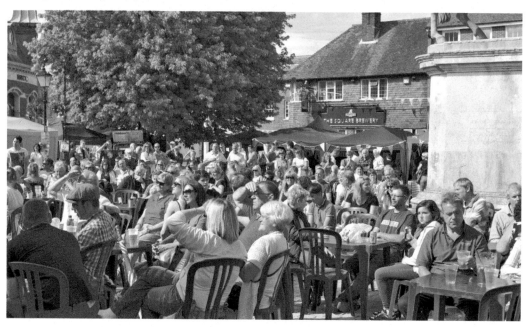

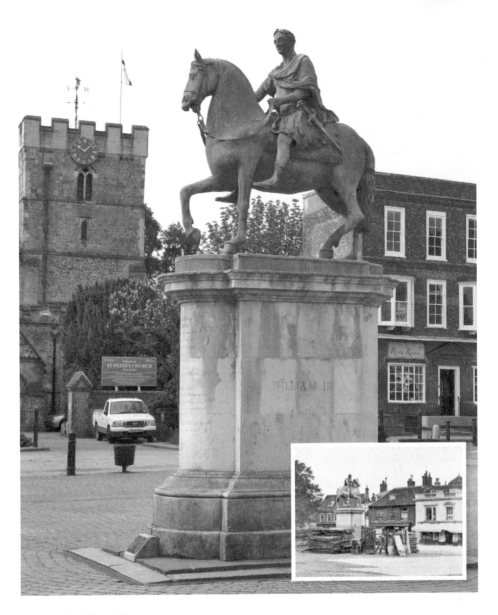

Statue of William III, *c.* 1912

Petersfield's iconic statue of William III was bequeathed to the town in the will of Sir William Jolliffe, the Borough of Petersfield's MP in the mid-eighteenth century, who had it cast as a symbol of Protestantism and liberty to confront the Catholic King James II. Originally standing in the courtyard of the Jolliffes' 'Petersfield House' in St Peter's Road, the statue was removed to the Square in 1812 and eventually bought by the Urban District Council in 1911. However, the whole lead-cast work gradually began to droop to the right; an overhaul in 1913 ensured its survival and, with the railings removed and the plinth renewed, William has lived another century for us to admire.

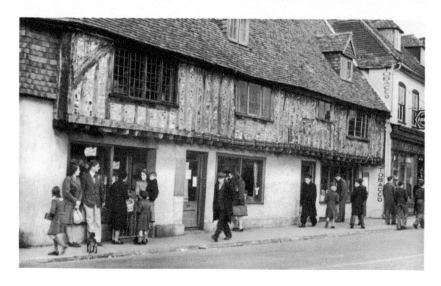

Nos 1/2 The Square, 1945

Officially Nos 1/2 The Square, but known to older residents as the Donkey Cart and nowadays variously as the Indian restaurant or the Piazzetta restaurant, this medieval corner building dates from 1534. From its size, its close-knapped flint infilling and its extensive timberwork, it clearly belonged to wealthy owners. Among these were at least two mayors of Petersfield. In 1918, it was rented by Dr Harry Roberts, who lived on Oakshott Hanger. he opened a bookshop here, driving into town in his donkey cart (*inset*) each day to see his *protégées*, the artist Flora Twort and her friends. In the 1920s, it was occupied for one year by the painter Stanley Spencer.

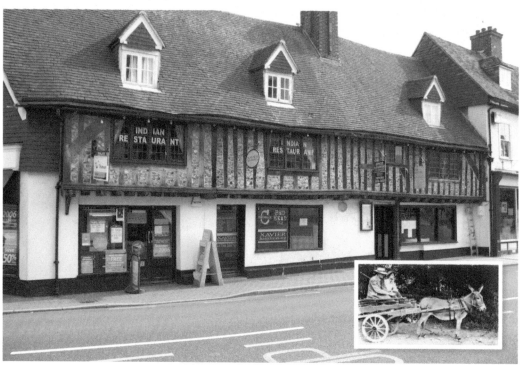

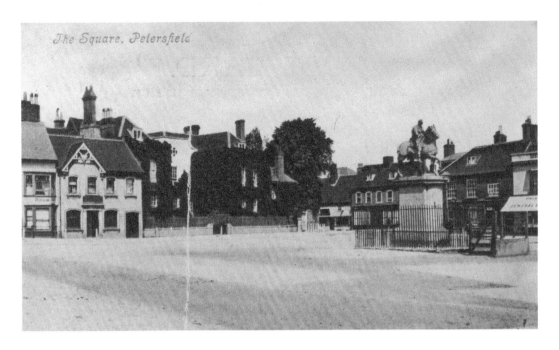

The Square, Petersfield

Castle House, *c.* 1912

The ivy-clad Tudor house in the north-west corner of the Square was Castle House, which had successively been the home of the Jolliffe, Bonham and Bonham-Carter families. When the latter moved to their new home at Adhurst St Mary in 1858, the building became a private boys' school. The headmaster from 1889 until 1895, J. Arthur Perkin, was a great sportsman who captained the town's football and cricket teams and established the golf club. He laid great emphasis on sport for his pupils – one of whom was Wyndham Halswelle, the 400m gold medallist at the 1908 Olympics in London. With the UDC refusing to contemplate saving the building, it was demolished in 1914.

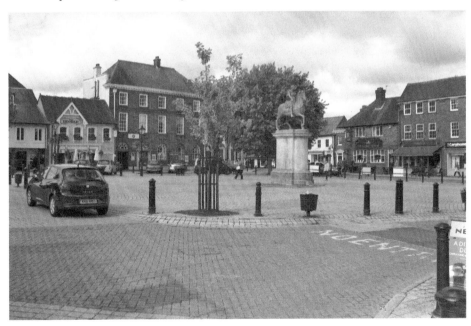

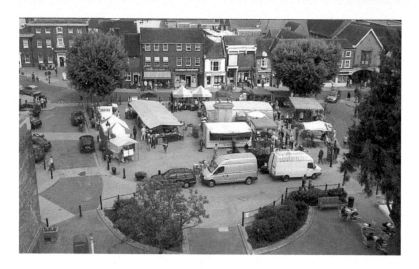

The Market Square, c. 1900

Petersfield's Market Square is one of only a few in the south of England still to accommodate a market as it has done since medieval times. The ancient stalls and private lock-up shops known as 'shambles' gave way to regular livestock markets in the eighteenth century and these continued until very recent times. The old Petertide Fair in July brought amusements of all kinds and sales of toys, but this was discontinued in 1903 when the Urban District Council purchased the market rights. As a focus of the town's public events, the Market Square now has, apart from its twice-weekly markets, regular annual festivities throughout the year, and it continues to be the venue for open-air, inter-denominational church services on Remembrance Day and at Christmas.

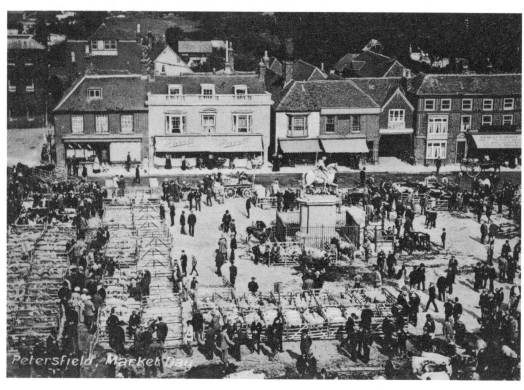

Petersfield, Market Day

The Old Cattle Market, *c.* 1920
Cattle markets, once the agricultural hub of Petersfield, were held fortnightly and attracted not only sellers and buyers but farmers, drovers, auctioneers, casual labourers and not a few onlookers. Local businesses, especially the pubs, thrived on the event, and alternate Wednesdays were a social occasion for all. However, when the Board of Agriculture condemned the Square as insanitary in 1906, Lord Hylton, the landowner of the Square, agreed to have it concreted over and repaved with a kerb. History repeated itself in 1962 with the condition of the Square again being brought into question. With tuberculin-tested and untested animals unacceptably herded together, increased competition from larger markets and a dubious future for the Petersfield slaughterhouse, the last cattle market was held in 1963.

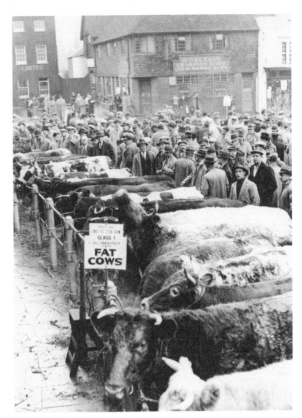

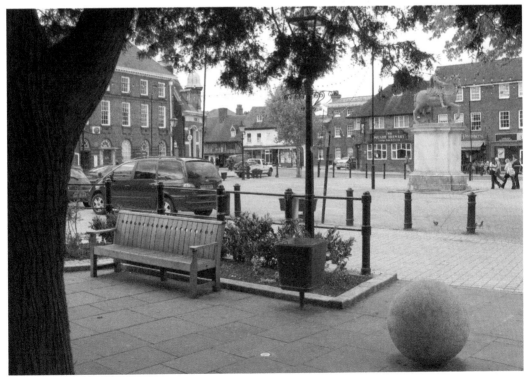

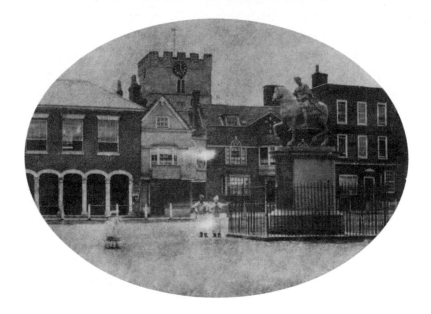

The Square, South Side, 1897

The two major landowners in Petersfield in 1898, Lord Hylton and Mr W. Nicholson (Petersfield's MP) announced their 'generous offer' to improve the Square by handing over to the UDC the houses they owned in front of the church, 'on condition that they pulled them down' and 'completing the improvement by laying out the site and forever keeping it as an open space'. The UDC approved the demolition, adding, 'from a sanitary point of view, the sooner the better'. At a stroke, the town lost its pre-Victorian town hall, the office of the *Hampshire Post* and an elegant Queen Anne-style town house. It gained a glorious view of the twelfth-century St Peter's, the origin of the town.

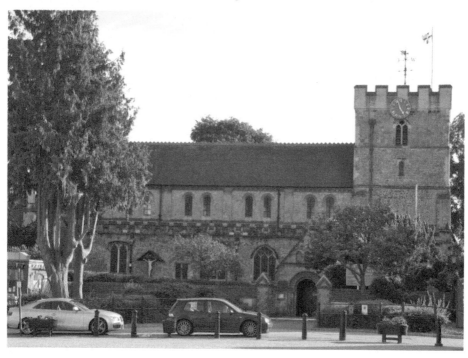

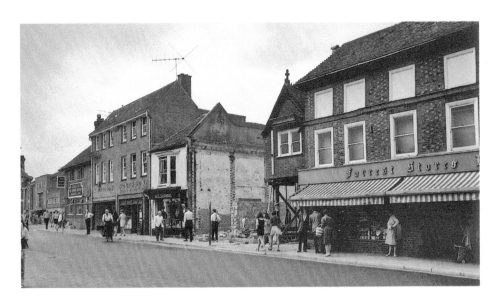

The Square, North Side, 1962

All four sides of the Square have undergone transformations in their turn; for the north side, it was the 1960s that sealed its fate, when an early Tudor house on the site, rebuilt with Georgian brickwork in the eighteenth century, was razed to make way for Barclays Bank in the centre position and the Fine Fare supermarket (the successor to Forrest Stores, which had dominated the scene from 1927 until 1963). Ramswalk was constructed on its eastern edge later in 1993. Happily, many of the Georgian brick frontages were retained and some of the old timber-framed interiors can still be seen inside the properties lying between Barclays Bank and the Edinburgh Woollen Mill.

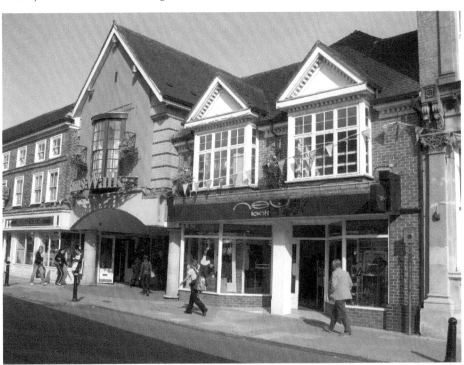

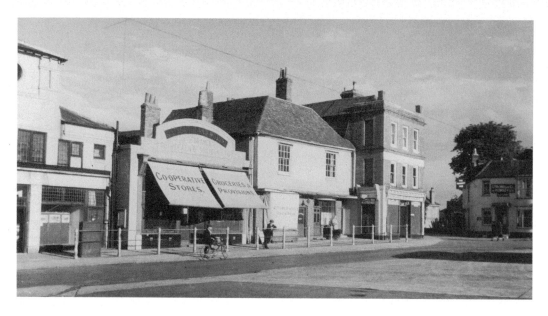

The Market Square, East Side, 1944

Next to the old corn exchange here stood the Golden Horse Inn, named after William III's horse when the statue arrived in the Square in 1812. In the twentieth century, the site housed the Co-operative Society stores from the 1920s until the 1990s, when the old building was demolished and became a three-storey department store. The ground-floor shops changed again in the early 2000s to what we see today, while the upper floors were transformed into fourteen flats. Several saddlers occupied the building next to Rowlands' until the Second World War. However, both these central shops were incorporated into the modernisation of 1953. Sadly, this involved the elimination of Dog Alley, situated behind the stores and entered from the High Street.

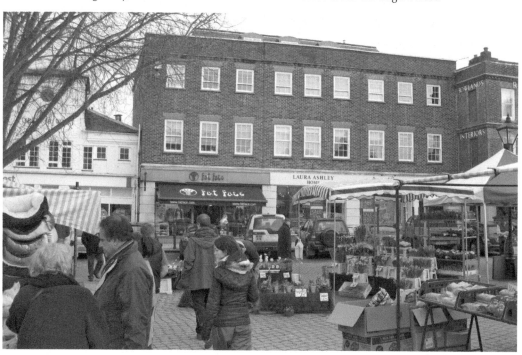

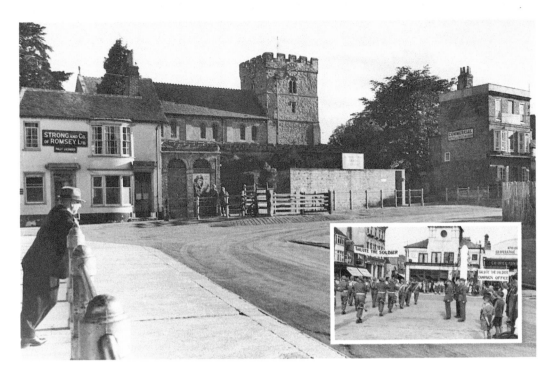

The Square in Wartime, 1944

Petersfield hardly suffered from wartime bombing, but several thousand Allied troops passed through the town *en route* to Portsmouth. They frequented the numerous pubs and were entertained at their own 'Home from Home' canteen in College Street. The boys of Emanuel School from south London and some Portsmouth schoolchildren were evacuated to the town. All these newcomers were successfully absorbed into the local community. The Square had one of the town's three air-raid shelters in front of St Peter's and occasional fundraising campaigns ('Salute the Soldier' dated from 1944) brought some distraction for residents. The cattle market, Savoy cinema and the Petersfield Musical Festival all functioned more or less as normal. Today, the Square hosts regular festivities throughout the year.

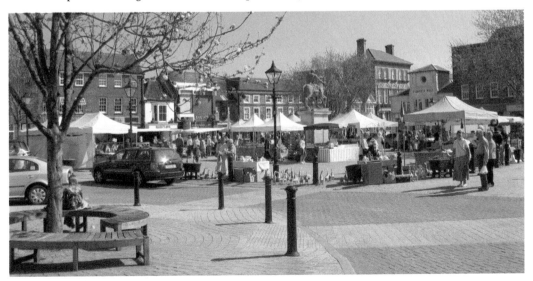

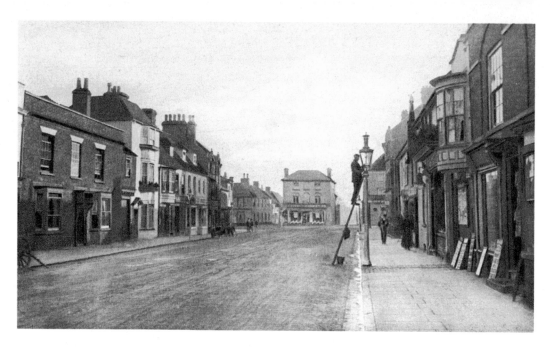

High Street, Looking East

Petersfield High Street forms part of the Norman and medieval core of the town. With its twelfth-century charter allowing the holding of markets, the High Street began to develop 'burgage plots' on either side to accommodate traders, their families and their shops. This Edwardian photograph shows little change from that pattern, but the arrival of motor cars in the 1910s and electric lighting in the 1920s brought modernism and a corresponding increase in the population (from around 3,000 to 4,000 in those twenty years). Original High Street burgage plots can still be seen in the Physic Garden and at the rear of No. 22 (on the far left of both pictures).

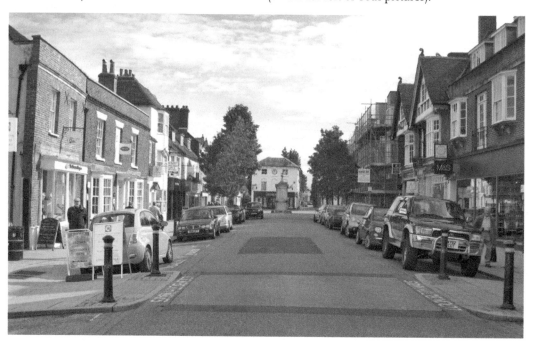

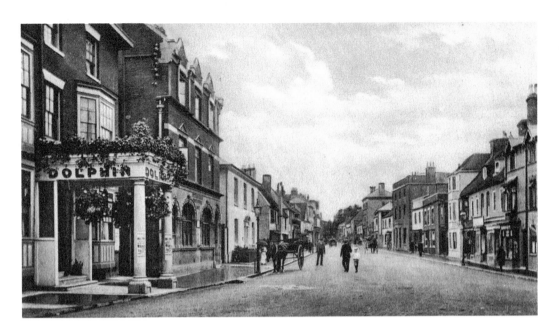

High Street, Looking West, 1898

These views demonstrate the worst excesses of the architectural damage done to the town in 1965: the seventeenth-century former coaching inn, the Dolphin, the late Victorian post office and an early seventeenth-century private residence, Clare Cross, were all demolished in that year by Raglan Developments Ltd. The town's most celebrated artist, Flora Twort, used her skills to depict the imminent destruction by sending a protest letter and drawing to the local press (*inset*). It was certainly no consolation to be told that the replacement building, Dolphin Court, won a design award from the Civic Trust in 1968 for its 'respect for the character of its surroundings'. A local architect described it as 'like a seaside marine building on an esplanade'.

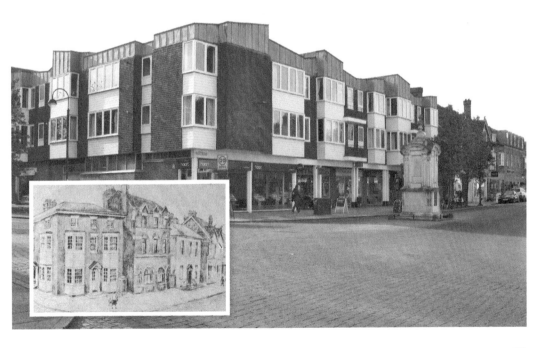

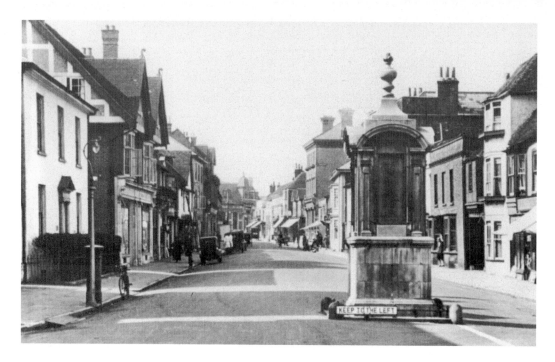

High Street, 1930s

At a first glance, little seems to have changed in the High Street since this picture was taken in the early 1930s. However, the seventeenth-century white-painted building on the far left, Clare Cross, was demolished in 1964 and carried a sad story with it. Its last occupant had been Charlie Dickins, a well-known Petersfield dentist who had also been the town's Scoutmaster for thirty-seven years. He had lived at Clare Cross since 1908; within two months of selling his lease to the developer Raglan, he died. The building on the right with the brick frontage is the new Boots chemist's built in 1936, which, with the adjacent Woolworths of 1934, displaced an eighteenth-century shop and burgage plot.

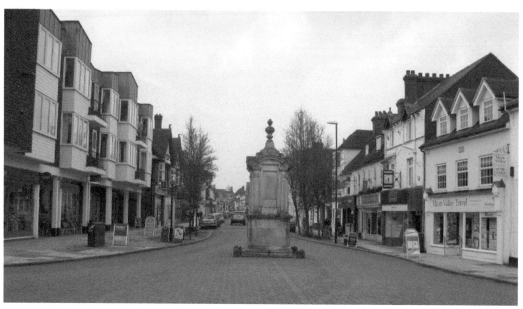

War Memorial, 1920s

The town's war memorial in the High Street was designed by Harry Inigo Triggs, the Arts and Crafts practitioner who worked from Station Road, Petersfield, with W. F. Unsworth and his son Gerald in the Edwardian period. Triggs (*inset*) had also been responsible for the restoration of William III's statue in the Square in 1913 and, in 1918, designed the Steep war memorial, a replica of a memorial he had designed while living in Italy. Interestingly, both ends of the High Street show an Italian influence in their architecture, the Natwest Bank, built in the 1880s, recollecting a stately Italianate palace. Petersfield's war memorial was erected in 1922 and now bears the names of all those fallen in two World Wars and subsequent conflicts.

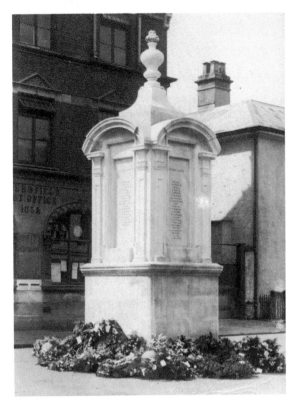

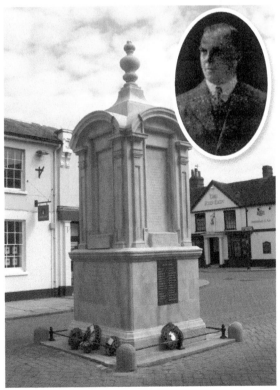

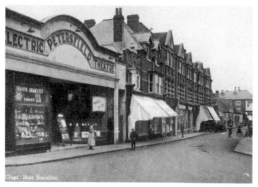
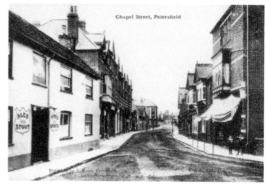

Chapel Street, Looking North

The old Swan Inn – whose sign now hangs in the town museum – gave its name to the adjacent street, previously called Back Street in Victorian times. The pub, once popular with the cycling fraternity as an overnight stopping place, was demolished in 1911 to make way for Petersfield's first cinema, the Petersfield Electric Theatre. Designed by a Petersfield architect, it held an audience of 400 on plush, tip-up seating, and for its opening film showed the Coronation of Edward VII. With its new electric lighting in the auditorium, it offered a highly popular and regularly changing programme of silent films. The rest of the buildings here have hardly changed in over a century.

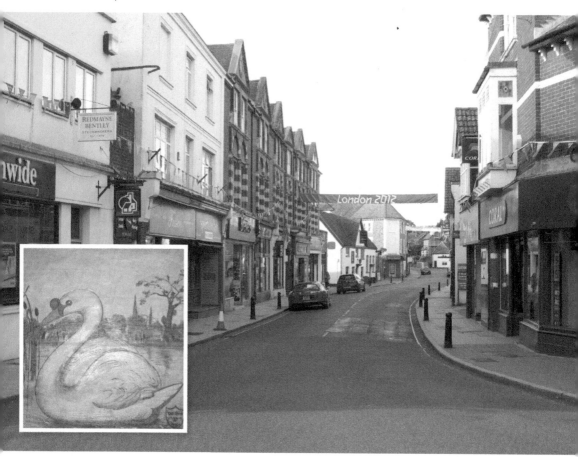

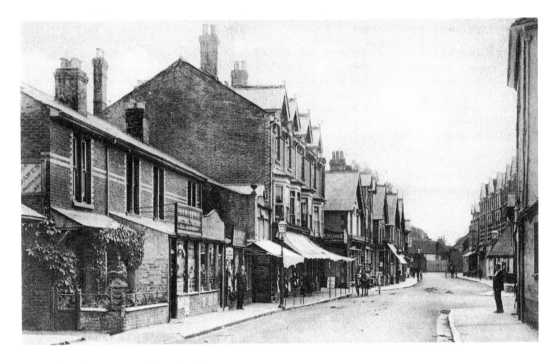

Chapel Street, Looking South

Once the main route to the north from the town centre, Chapel Street was named after St Andrew's chapel, which stood at the Station Road (then named Cowlegs Lane) end of the street in the sixteenth century. The property and land around it had been granted by Edward VI to Edward Fynnes (Lord Clinton and Saye), afterwards Lord High Admiral under Elizabeth I, who owned many monastic and church properties in England. No trace of the chapel now exists, but another Elizabethan building nearby is the Old Drum, recently dated as late sixteenth century in origin.

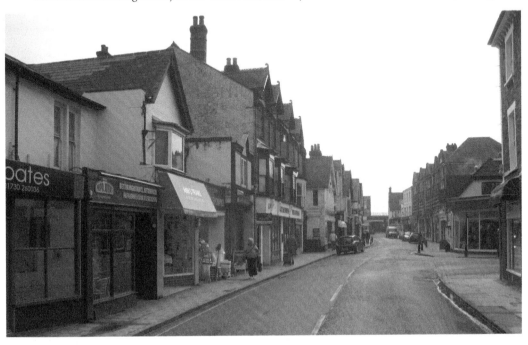

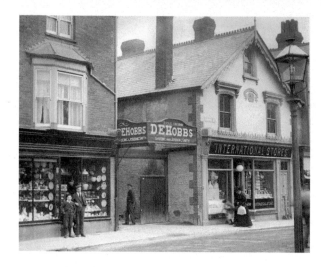

Chapel Street and Hobbs Lane

D. E. Hobbs was a 'shoeing and jobbing smith', whose smithy was situated in the present bakery building at the end of the lane. He owned the premises on either side of the alleyway – where horses waited to be shod – and his monogram is still visible high up on the façade of the shop on the right. He was also chairman of the Urban District Council 1921–23 and was very active in local politics. The International Stores was a leading chain of grocers founded in London in 1878. Its Petersfield shop was popular for a century; it closed in 1985. The building will be reconstructed in 2013 to comprise shops and flats.

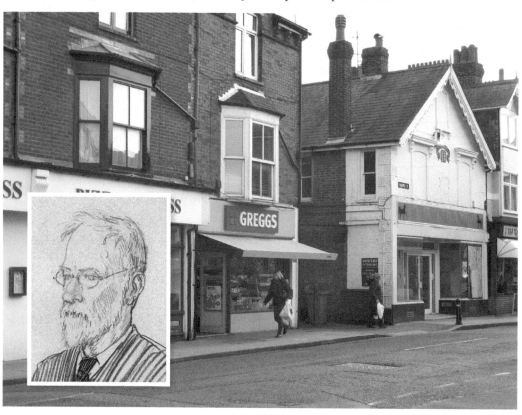

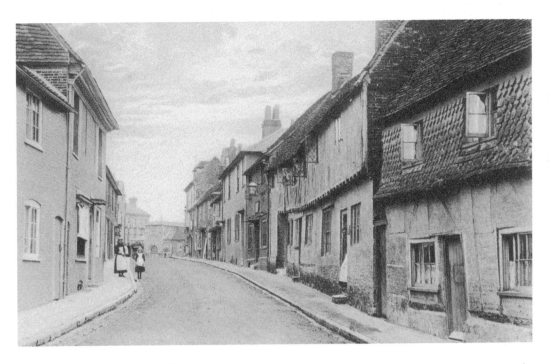

Sheep Street, South End

Situated in one of the best-known streets in Petersfield, these fifteenth-century properties are rare examples of Wealden houses in Hampshire. The present four small houses (Nos 18–24) once formed two larger properties with a common timber-framed structure and prominently jettied first floors. All of the houses on this side of the street were bought by the Jolliffe family in 1732 to secure them votes in Parliament, and the Jolliffes' own house-numbering can still be seen under the canopies of Nos 6 and 8 (*inset*). The upper floor of No. 18 differs from its neighbour because its roof was raised and its façade covered with 'mathematical' tiles (false bricks) to avoid the brick tax, introduced in 1784.

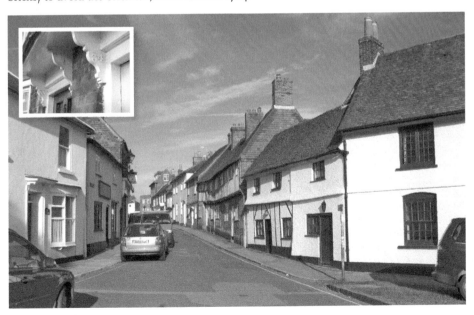

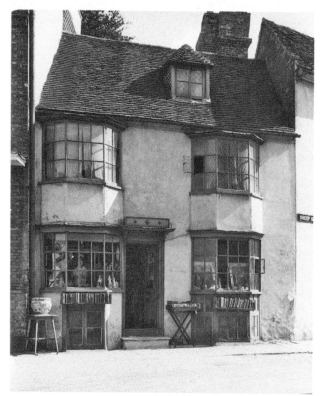

Sheep Street, North End
Buildings on this site, officially
No. 25 The Square, go back
to the Tudor period. During
the eighteenth century, it was
variously occupied by a mayor
of Petersfield and also two of the
town's MPs. Since mid-Victorian
times it has been owned by
various artisans and, in the early
1920s, was briefly home to the
artist Stanley Spencer. From the
1930s until the 1950s it was a
bookseller's and antique shop.
In the 1990s the property was
transformed into an annexe of
the solicitors MacDonald Oates,
whose offices stood next door at
No. 24. It has since reverted to
being a separate private residence.

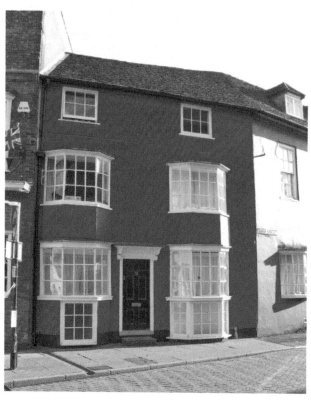

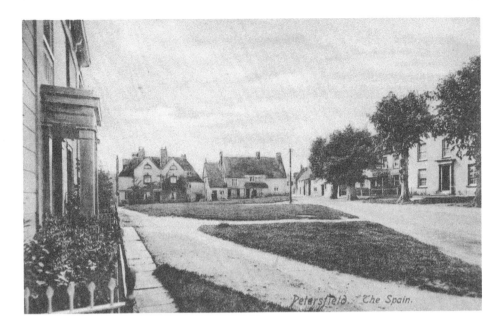

The Spain, 1950s

'The Spain' puzzles residents and visitors alike: was it connected to Spanish wool merchants in medieval times? Does it refer to spayed sheep or other animals? The most likely explanation is that it derives from an old word for a roof tile. This would relate to the ancient craft of tiling which, along with brick-making, was practised in the Petersfield area. It particularly thrived in Victorian times, when roof tiles gradually replaced thatch. The older photograph shows the original three-bay Wealden house (*right background*) called Tullys, which dates from 1442 and whose fourth (*far right-hand*) bay was demolished in the 1960s to allow the road to be widened.

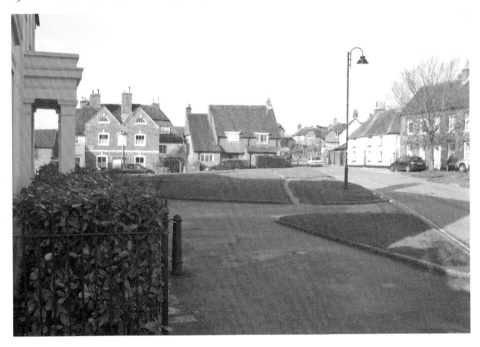

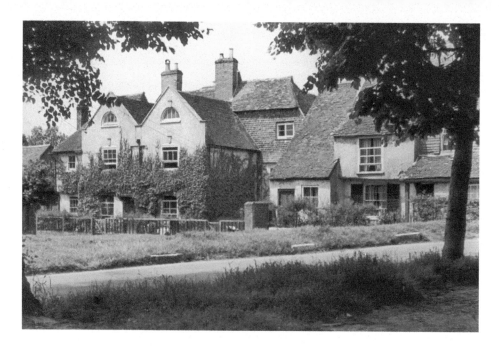

Goodyers and Tullys

Two of the oldest buildings in The Spain are Goodyers (*left*) and Tullys. John Goodyer was considered England's best botanist. He moved here in 1625 to manage the Mapledurham estate for Sir Thomas Bilson, the son of the Bishop of Winchester. During the Civil War, Goodyer was given a protection order by Lord Hopton, so that his horses and men were spared for local agricultural work. In his will, he left his estates for the funding of the Weston Charity, which still helps young people in the Petersfield area. The medieval house Tullys had a malthouse in its grounds until 1898 and stood on the old boundary between Petersfield and Buriton parishes.

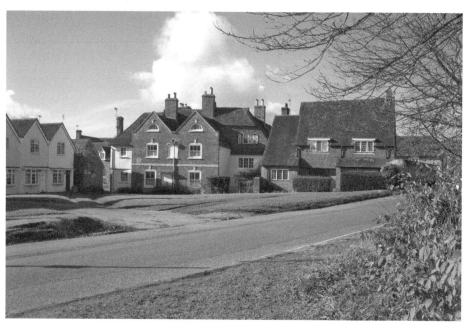

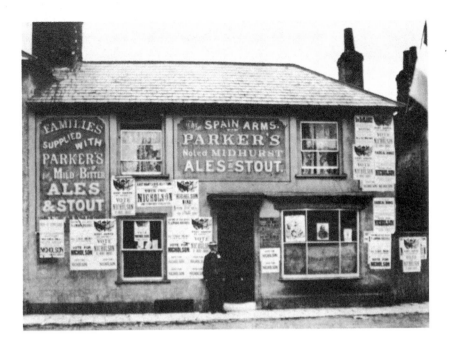

No. 1, The Spain

The 1897 picture of this house reveals the seedier side of Victorian Petersfield, when a surfeit of pubs brought some unwelcome guests to their premises. The Spain Arms was one such establishment, here plastered not with Queen Victoria's diamond jubilee mementos but with posters for a by-election which brought in W. G. Nicholson, the son of the sitting MP who had died that year. Seven years later it was the scene of a brawl between immigrant Italian labourers and local workmen, all resident at the pub; one of the Englishmen suffered a lethal blow to the head and died at the workhouse days later. Today, the house is a very respectable bed & breakfast establishment, with its ghosts...

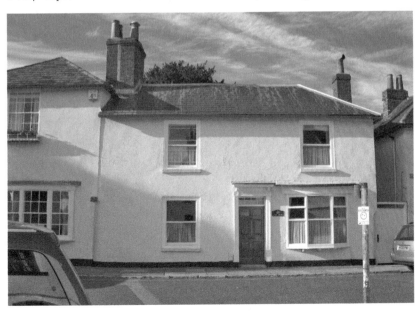

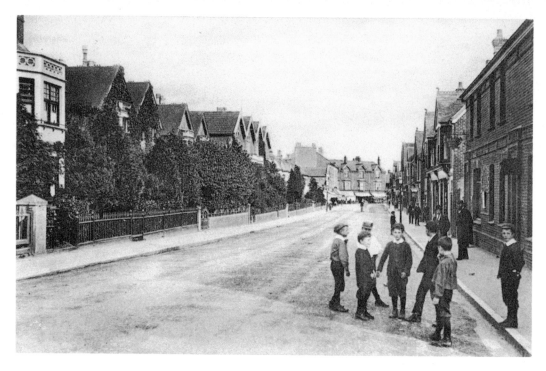

Lavant Street, Looking South-East, *c.* 1900

The north (left-hand) side of Lavant Street was almost entirely residential, while the south side contained some shops, including those of Mr Archibald Emm (toys and china), Allsworth (ironmongery), and Llewellyn Bradley (stationery) on the corner, whose name can still be detected on the brickwork at the back. A bull, destined for the market, once escaped from its drover as he drove it down Lavant Street from the station; it entered Mr Emm's shop! The despoliation of the north side with jerry-built add-on shops occurred in the 1960s, although some of the original house façades can still be seen behind.

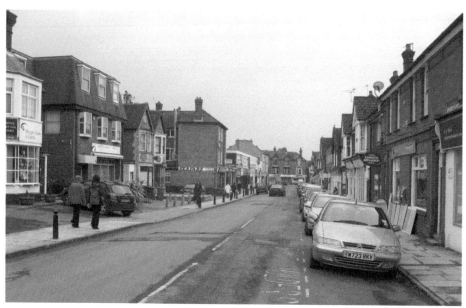

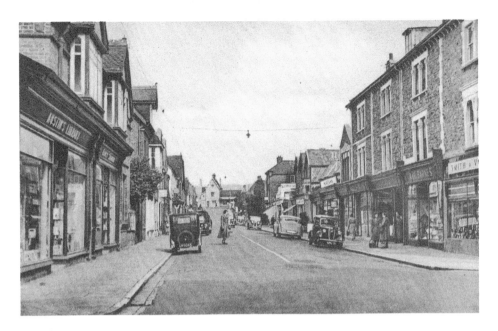

Lavant Street, Looking North-West, *c.* 1900

Lavant Street was built in the 1880s in order to connect the town directly with the station. Along the west (left-hand) side of the street, the earliest traders to move here were four ironmongers. The two Tew brothers owned a cycle shop and a motorcycle repair shop with workshop and petrol pump behind, and there was also a small factory at the rear of the Misses Munday's house where cattle food and embrocation were made. The well-known Petersfield photographers, Emily and Ethel Pickering, had a shop and studio here in the early twentieth century, and the Blue Peter café and guest house was run by Mr and Mrs Taunton for fifteen years in the 1950s and '60s.

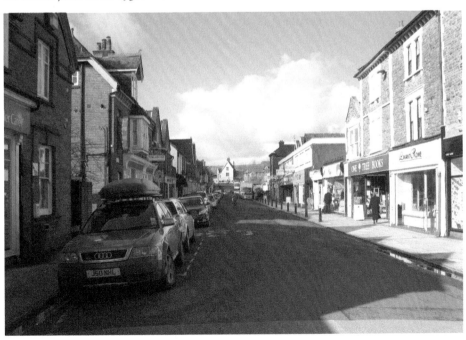

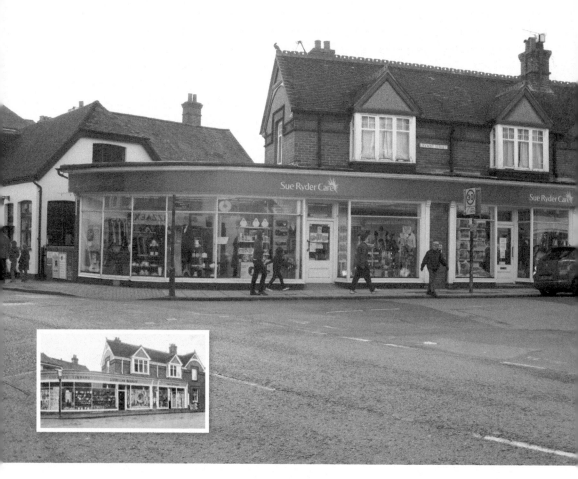

Lavant Street Corner

Mr Llewellyn E. Bradley first occupied a single shop on the other side of Lavant Street in Edwardian times, calling himself a stationer, bookseller and newsagent; his shop was a 'fancy repository' of goods of all descriptions and doubled as the 'Lavant Street Post Office'. After great success, he moved into this corner site opposite and his premises became a lending library. Because of its operation as a post office, there is an inbuilt letter box here. The name 'Bradley' can still just be made out in the brickwork on the rear wall of the shop, where the Drum Stream runs past.

London House, Lavant Street

For half a century from 1900, this corner site was the home of W. J. Fuller, 'family grocer, provision merchant, baker and confectioner', specialising in tea and coffee. Fuller was also a pillar of the Congregational Church. A strict disciplinarian over his twenty-five staff, he was an opulently dressed gentleman who bowed a welcome to all his customers. He was the first Petersfield shopkeeper to incorporate a drawing (*above*) into his newspaper adverts in 1906, and he also successfully campaigned for a half-day closing in the town. During the Second World War, children would buy warm lardy cake at the shop on the way home from school. It has since changed hands many times and been closed for long periods without an owner.

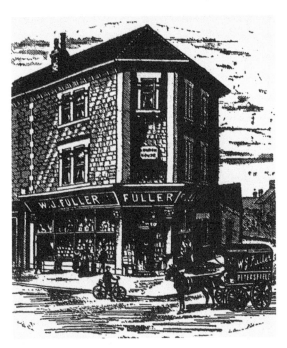

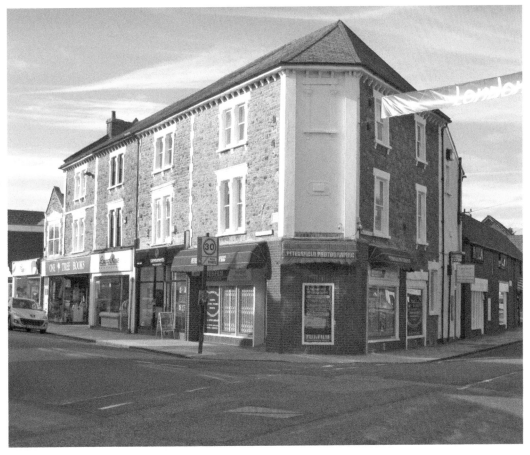

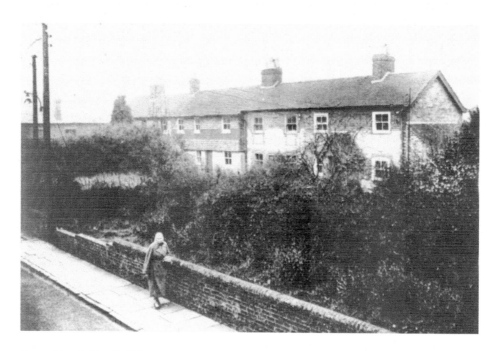

Swan Street, North Side

These six cottages were demolished by the Raglan Property Trust in 1961 to make way for their £100,000 office block, Swan Court, Petersfield's costliest property at the time. Containing nine suites of offices, it was intended to harmonise with existing properties in the street and with the traditional character of Petersfield. However, rents were set high and the building remained empty for four years, denying the council its rate revenue and crippling the local economy. Despite the criticisms, Raglan considered the building their showpiece and had intended to open up the view to the South Downs from it; unfortunately, ten years later Castle Garden was built opposite and blocked any such prospect.

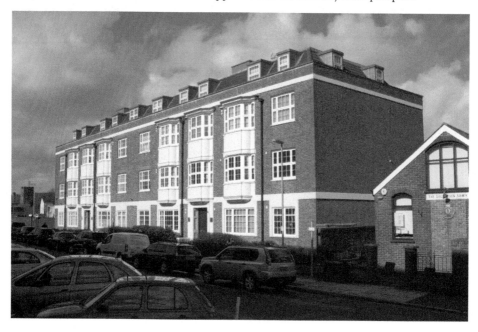

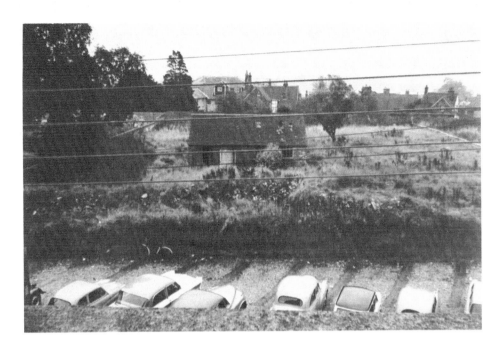

Swan Street, South Side

The depressing state of the garden behind the long-demolished Castle House lent itself readily to speculators: a Petworth-based firm of builders bought the site from Raglan and, in 1973, constructed the development of forty-eight luxury flats named Castle Garden. Its austere outward appearance, however, did not enamour itself to Petersfield residents, who nicknamed it 'Colditz'. The two major Swan Street developments represented the final chapter in the Raglan story in Petersfield: the town's heritage had been severely diminished by the indiscriminate and piecemeal substitution of its old properties in the High Street, the removal of cottages and shops, and the creation of emptiness where there had been life.

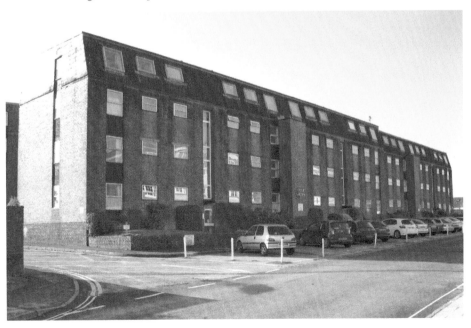

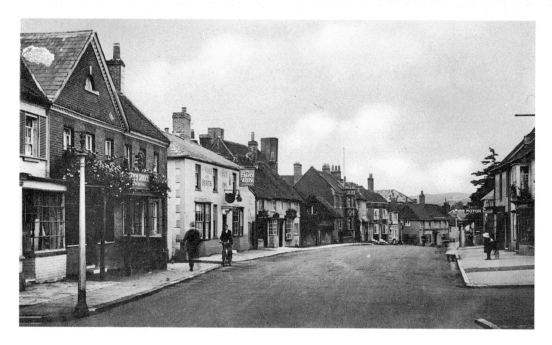

Dragon Street

The absence of traffic dates this picture to a time long before the A3 became a nightmare to motorists passing from London to Portsmouth. Dragon Street has been called 'the first Petersfield bypass' as it took Victorian mail coaches away from the town centre on their way south. The street name derives from the late seventeenth-century Green Dragon Inn, which stood on the west side of the street but transferred to the other side and became the Sun Inn from the early nineteenth century until 1977. The majority of the buildings on this east side date from the seventeenth century and reflect the wealth of their original owners.

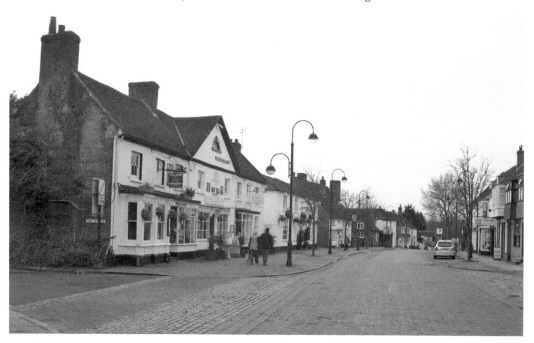

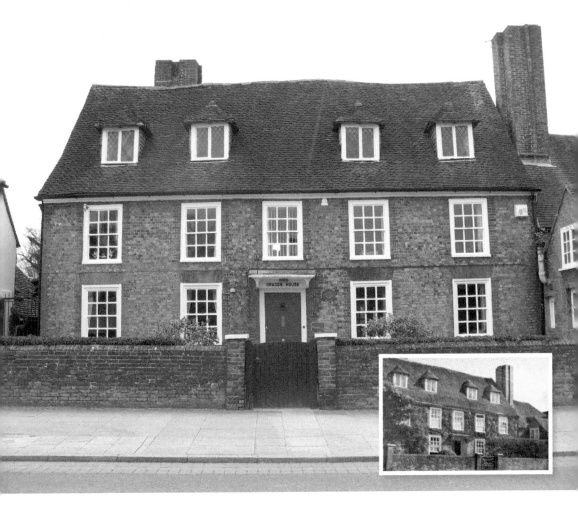

Dragon House, 1950s

The Georgian brick frontage of this elegant house hides a mixture of styles. It has a timber frame which dates from around 1625. In the eighteenth century it was the home of the Patrick family, brewers and stewards of the Jolliffe estate. A gazebo in the garden dates from the same period. It was the Green Dragon Inn (hence the name of the street) in 1697 and housed the maltster and brewer of the inn. It was converted into a private dwelling in the Victorian era and was the home of the Petersfield architect H. T. Keates in 1893. Since the 1930s it has been the home and surgery of a succession of dentists.

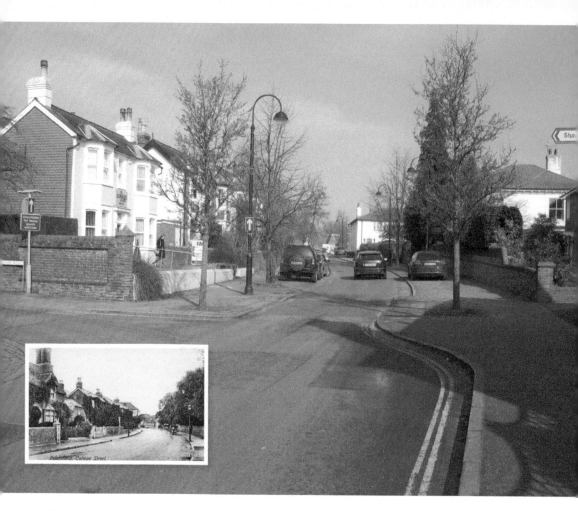

College Street, c. 1905

Once part of the main London–Portsmouth highway through the town, College Street comprises many listed buildings dating back to earlier centuries, including Petersfield's oldest private house (fourteenth century), a timber-framed former public house (sixteenth century), and a group of seventeenth-century cottages. The street was the home of early evangelical churches: a Congregational chapel dating from 1801, Victorian Petersfield's first Sunday school (which used to stand where the present United Reformed Church building of 1883 is now situated), and a Plymouth Brethren meeting hall. The private housing development known as The Village was constructed in the early 1980s after the demolition of two large mansions on a derelict piece of ground, once a garden centre.

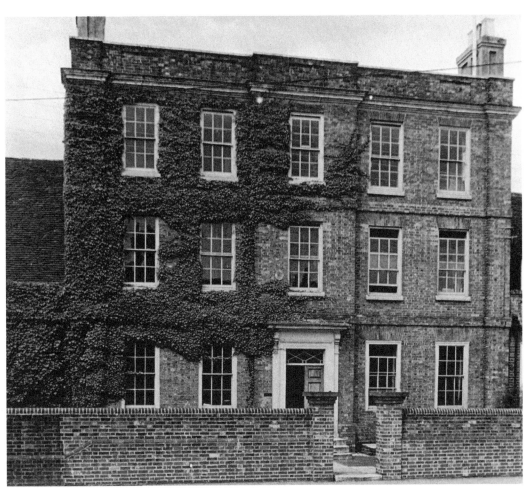

College Street, North End, 1940s

College Street is named after the fine Georgian building of the original Churcher's College, built in 1729. It was the main approach to the town from the north before the construction of Tor Way and formed part of the ancient hamlet of Stoneham. Richard Churcher (*inset*) founded the College for a dozen boys, who would then be apprenticed to shipmasters of the East India Company; they were taught English, mathematics and navigation. The school closed in 1877 and reopened in its present Victorian Gothic premises on Ramshill four years later. The Old College became a commercial hotel in the 1920s, was privately owned in the 1930s, and housed district and county council offices until 2012.

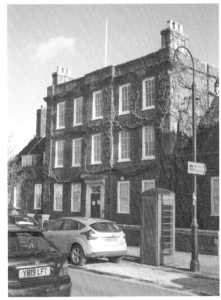

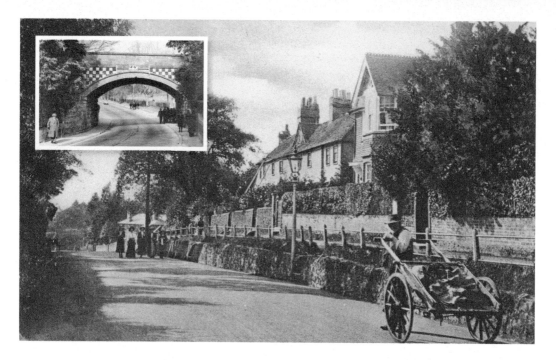

Ramshill, c. 1900

Sheep farming on the Downs had been a major contributor to the town's economy since its foundation in the twelfth century, and sheep were a common sight in the town centre, where they were sold at the markets in the Square. It is from this legacy that the streets of Ramshill and Ramswalk take their names. This bridge at the bottom of Ramshill was constructed in the 1860s to carry the Petersfield to Midhurst railway line eastwards along the Rother Valley. Several parts of the embankment still remain within the town, this section being adjacent to the community centre. The bridge itself was demolished in 1959; it took all night for the Army to blow it up with explosives.

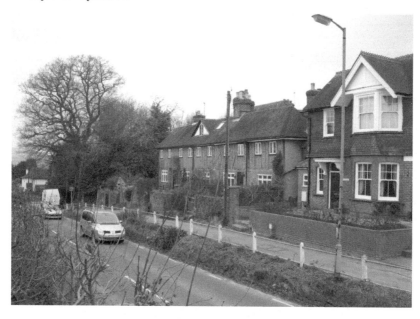

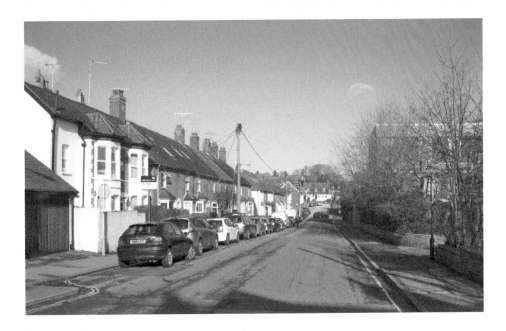

Charles Street, c. 1910

Although the railway came to Petersfield in 1859, it was some years before the roads linking it to the town were built. Lavant Street, Charles Street and much of Chapel Street were built in the 1880s by John Gammon, on land that had been purchased from the London & South Western Railway Company after the Midhurst branch line was completed and opened in 1864. Naturally, this road-building programme caused a noticeable increase in the population of the town, which reached just under 3,000 in the 1890s, up from approximately 2,300 in 1881. Little changed here until 1972, when the telephone exchange was built on the corner with Swan Street, replacing a semi-derelict site.

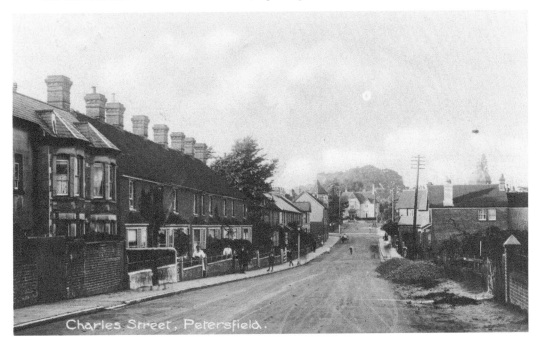

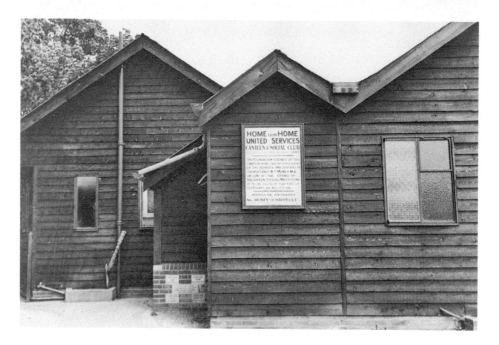

College Street, 1941

Early in the Second World War, the provision of meals in Petersfield for the Portsmouth refugees, evacuated London schoolchildren and passing troops became critical. Kathleen Money-Chappelle, an accomplished musician and dynamic entrepreneur, stepped into the breach with a proposal to build a canteen specifically for servicemen on the old Luker's brewery site in College Street. Within four months, sufficient money was raised and the 'Home from Home' canteen was opened. Thousands of Allied troops enjoyed the relaxed comradeship, meals and entertainment provided by volunteers under the general supervision of Mrs Money-Chappelle. After the war, the canteen was demolished to make way for the new Tor Way one-way road system, but its foundation stones are preserved alongside the town hall today.

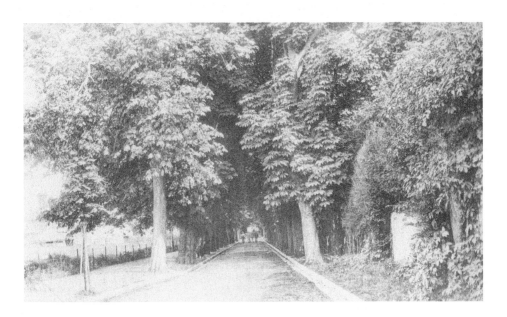

The Avenue

This southern end of John Worlidge's garden (*see p. 50*) became a private walk in the grounds of the next owner, John Shackleford, in the mid-eighteenth century. It was laid out as a private road in 1894, with chains barring the way to the public. These were removed in 1920, thus creating a through road to the Heath Pond. In the 1960s, a new infants' school was proposed for the green space here, but public opinion won a victory to save it as a public recreation ground instead. A new pavilion was built in the 1980s; it serves both as a recreational area for the users of the playing fields and as a community facility for the town.

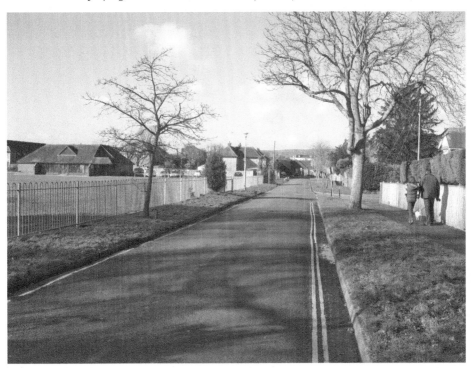

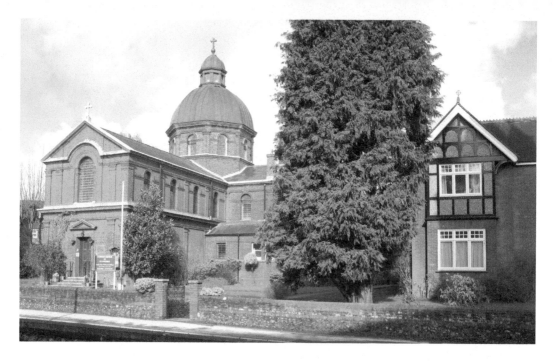

St Laurence's Catholic Church

In 1885, the wealthy family of Laurence Trent Cave bought and settled into the Ditcham estate outside Petersfield. Sadly, Ditcham House itself was destroyed by fire in 1888, but it was rebuilt within a year. Next, Mr Cave bought an acre of land in Station Road and had St Laurence's built there in 1890. The church is run by the Benedictine monastery of St Laurence at Ampleforth in Yorkshire; however, it owes its name not to the patron of the mother monastery but to the fact of its founder being a namesake of that saint. The whole cost of St Laurence's, built in the Italian style of architecture, was defrayed by Cave himself, who was received into the Catholic Church two years later.

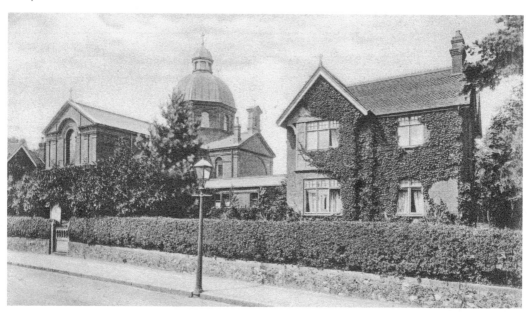

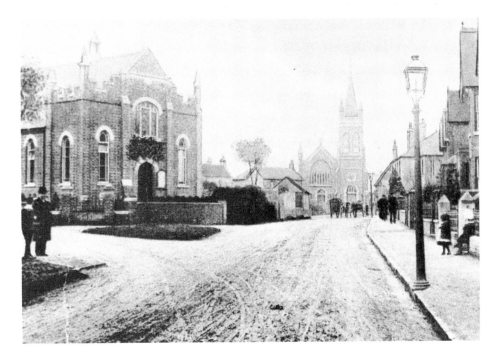

The Methodist Churches, 1903

The first small Wesleyan Methodist chapel in Petersfield was built in New Way (now St Peter's Road) in 1871. In the space of just two years, at the start of the Edwardian era, the Primitive Methodists built their chapel at the corner of Station Road and Windsor Road in 1902, and the impressive new Methodist church in Station Road was opened in 1903 (and their former chapel sold to become what is still St Peter's church hall). The two forms of Methodism continued to operate in parallel until 1940 when their merger was agreed and the old Primitive chapel was sold. The building now houses Petersfield's Masonic lodge.

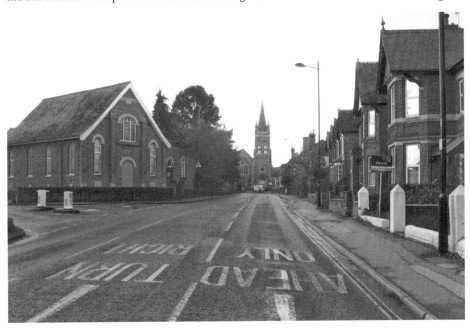

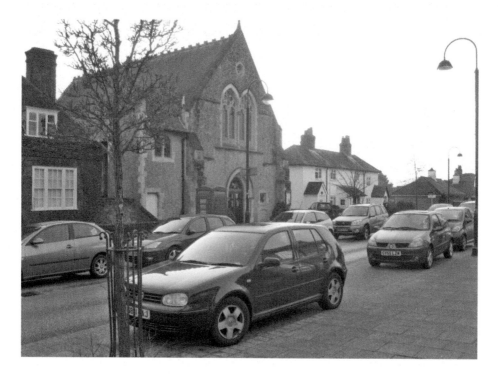

The United Reformed Church, c. 1890

The present building dates from 1883 when an old Congregational chapel was demolished to make way for a grander church, with its adjacent Sunday school. The school, the first Sunday school in Petersfield, closed in 1895 and was finally demolished in 1967, but the new Congregational church still thrives today as the United Reformed church. This was as a result of an election in 1972, when it chose to link with the Presbyterian church in Liss. The school was a so-called 'British School' and had originally been Quaker by denomination, but it was eventually subsumed into the Board School regime after the 1870 Education Act, which, for the first time, provided schooling for all children in the town.

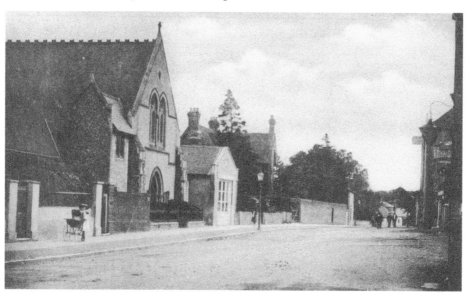

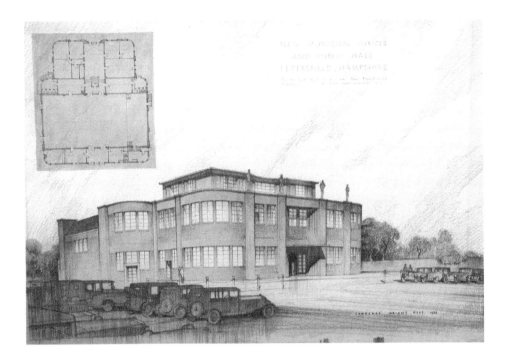

The Town Hall, 1947

The creation of a 'Municipal Offices and Public Hall' building had been the brainchild of Dr Harry Roberts, a London GP who periodically lived on Oakshott Hanger between the 1920s and the 1940s. The demand for a new town hall, together with a desperate need for a good municipal venue for music and drama productions, led to the proposal for a joint venture funded by public subscription. Within barely more than a year, sufficient money had been donated to proceed with architectural plans and, although Dr Roberts' plan for a third storey housing a public library was abandoned, the new building was opened in 1935. The hall became the Festival Hall when additions were made in 1979.

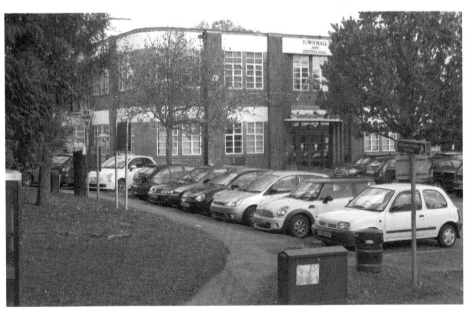

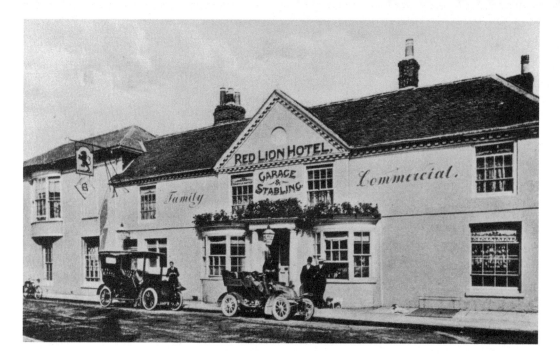

The Red Lion, *c.* 1915

Although the original coaching inn on this site dated from the seventeenth century, the present frontage was rebuilt in the late eighteenth century, when College Street was constructed to allow traffic to bypass the town centre. Military, particularly naval, traffic was passing through Petersfield on its way to and from Portsmouth. The name 'Red Lion' dates from 1734, when it became the property of John Jolliffe. The old Red Lion 'tap' – once licensed as a separate public house to serve local people – still occupies its position behind the pub fronting Heath Road, now forming part of it. This bar was the favourite haunt of traders at the horse fair and taro fair every October.

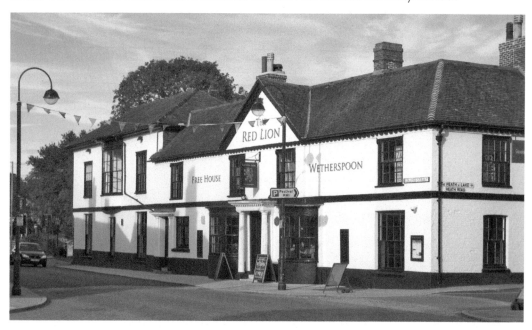

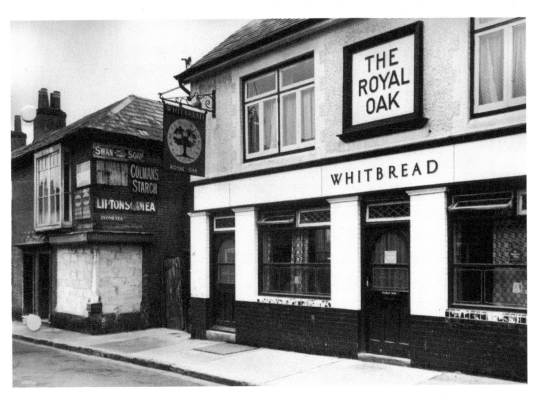

The Royal Oak, *c.* 1960

Although Sheep Street was probably named after a corrupted form of Ship Street from a public house of that name that stood on this site, the pub later became the Royal Oak and remained so for many generations. There was also a Spiritualist chapel in the street, which like the adjacent cottages and the pub was timber-framed. By the 1960s, however, the terrace of seven cottages had lain derelict for seventeen years and was demolished by the Raglan company, which also proposed, unsuccessfully, to drive a road from Sheep Street through to Swan Street and erect a four-storey block of shops on the 'island' between the two streets. In 2011, the pub was renamed the Black Sheep.

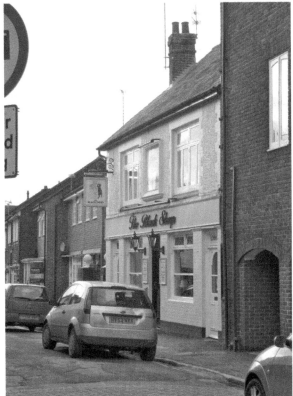

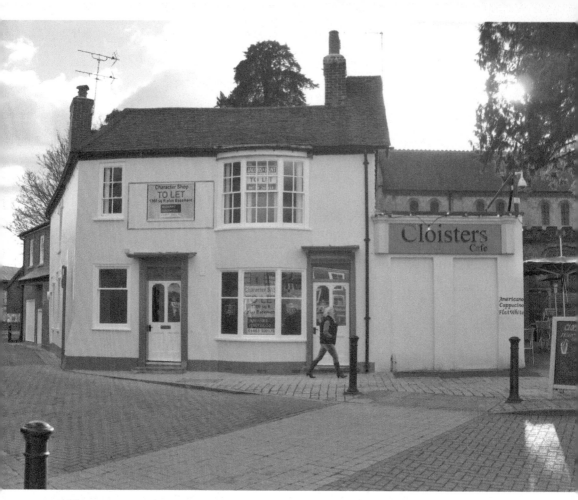

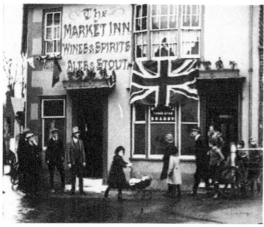

The Market Inn, 1913

This site, once referred to as the Lords House because it was the home of the Lords of the Manor of the Borough of Petersfield and many other prominent individuals of the town, dates back to the late sixteenth century. The first record of an inn here was in 1867, when the licensee of the Market Inn was Thomas Fitt. He was also a coachbuilder, as was his successor, Henry Cox. Coachbuilding was a trade conducted in this part of the town in Victorian times and there were workshops on both sides of St Peter's Road at this point. The Market Inn ceased operating as a public house in 2006 and was transformed into a shop in 2013.

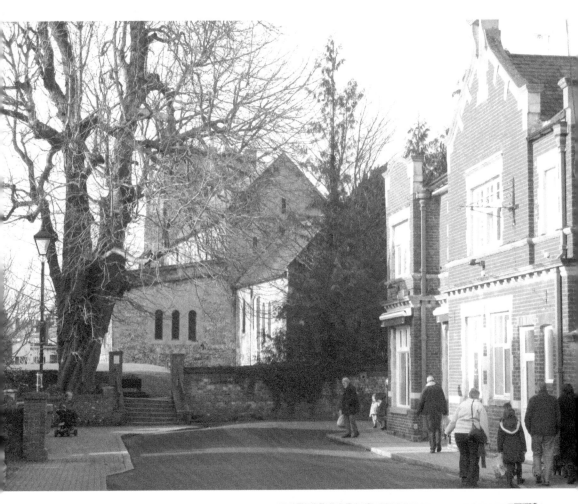

The Bell Inn, *c.* 1910

An old print of this view dates back to the 1820s, when there was already a Bell Inn on the corner site (*right*). It was then a Georgian Gothic building with a crenellated gable and an ogee-pointed doorway onto the New Way, renamed St Peter's Road in 1894. This rear entrance with steps to St Peter's was cut by John Jolliffe in the mid-eighteenth century to give his family a direct entrance from their residence, Petersfield House, to their own gallery in the church. The house stood where the police station and infants' school stand today. Old signs for the Bell Inn can still be read in its windows and on a side wall.

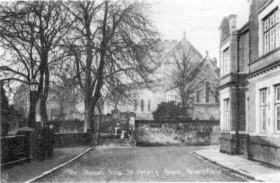

The Church from St Peter's Road, Petersfield

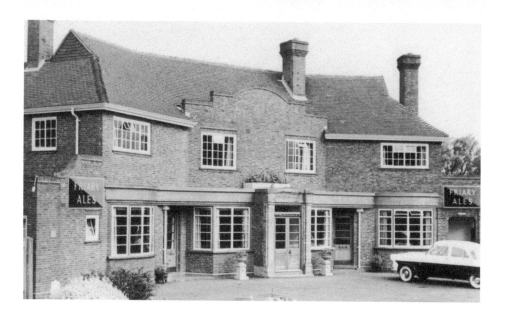

The Jolly Sailor, 1930s

Until recently, the Jolly Sailor stood at a critical junction on the Causeway, at the southernmost entrance to the town. It had the typical appearance of a building of the 1930s, although there had been a public house here in the early Victorian period (*inset*). It would have attracted many a traveller between London and Portsmouth, especially those on foot. The site featured in the Petersfield Local Plan of 1982, when the construction of 125 houses, to form the Rivers estate, was proposed by the company Galliford Sears. The pub was finally taken over by Whitbread until its demolition in 2011, when two houses and six flats were built on the site.

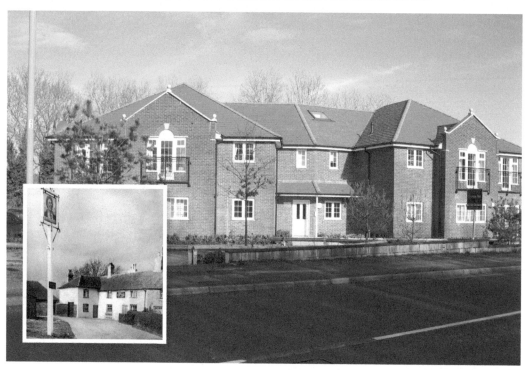

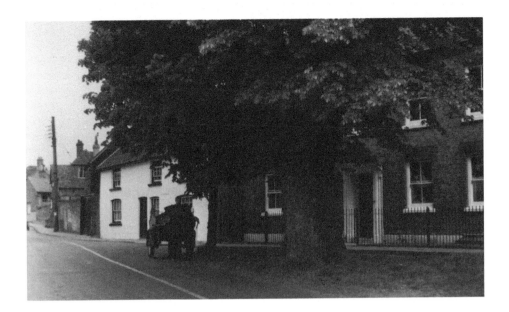

The Bricklayers' Arms, 1930s

No. 9 The Spain dates from the sixteenth century and was once divided into three tenements. In 1842, it was restored as a single house and opened as an alehouse. In common with ten other public houses in Petersfield in Victorian times, it was owned by Henty's, the Chichester brewers. National measures to combat drunkenness led to the Licensing Bill of 1908, which soon brought about the closure of many inns in Petersfield – a town boasting one pub for every 155 people in the town, the equivalent of having over ninety such establishments today! Petersfield also demonstrated strong support for the temperance movement of the 1890s. The Bricklayers' Arms became a private residence again in 1905.

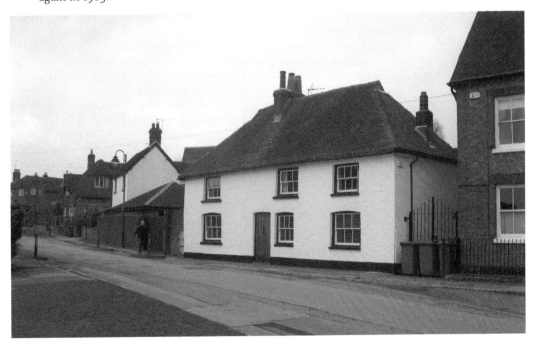

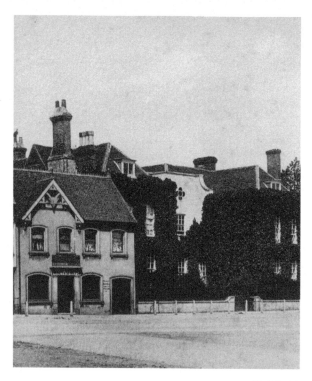

The George Inn, *c.* 1912

The sole remaining old building on the west side of the Square, the George has long outlived its neighbours, Castle House and the temperance hotel (*pictured above*). It was the only inn in the Square in the mid-seventeenth century, was owned by John Jolliffe in the eighteenth century, and was radically altered and reduced in size in the nineteenth century. The old tap remained as an inn, taking in lodgers, while the adjacent premises became a coffee tavern and temperance hotel. The George's position lent the old cattle market traders and farmers the opportunity to conduct their business over a few beers at the bar. Most remarkable, perhaps, was the fact that it existed alongside a temperance establishment for nearly fifty years.

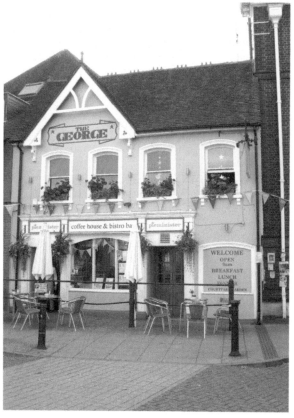

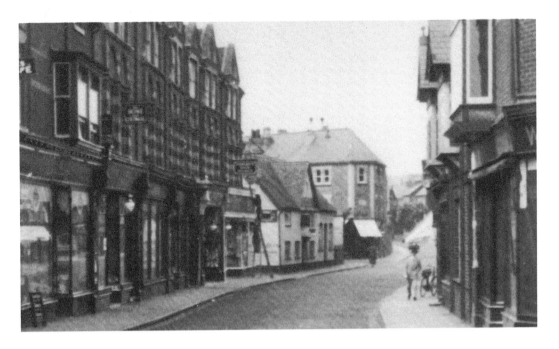

The Old Drum, 1920s

The variations on the name of this public house – the Drum, the Drummer and the Old Drum – all refer to the Drum River, which passes through its garden, and to Drum Mead, a farm which stood here in medieval times. During the Victorian period, it offered accommodation to members of the Cyclists' Touring Club and other visitors, and also boasted a bowling green. The novelist H. G. Wells regularly dined and wrote here. It has changed owners many times since the Second World War and has now been refurbished as a pub, restaurant and bed & breakfast establishment. The building itself has recently been dated to the Elizabethan period.

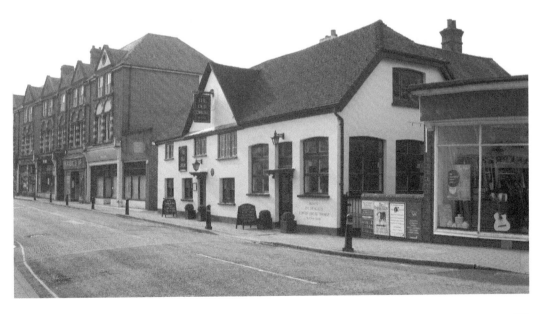

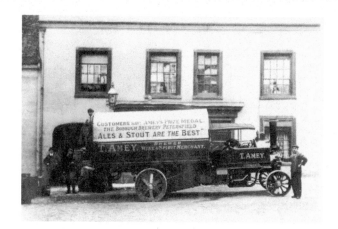

The Borough Brewery, 1920s

Petersfield's location among the nearby hop fields of Weston and Buriton had led naturally to the development of breweries in the town in the eighteenth century. From Victorian times the Luker and Amey families supplied ales to the public houses they owned until well into the twentieth century. The brewery in Frenchman's Road, founded by Thomas Amey in the late 1870s, had its own private siding beside the railway track as it crossed Borough Hill. After his death in 1896, Amey's daughter Elizabeth took over and expanded the business to include twenty pubs in the area. The firm closed in 1951 and the site eventually transferred to Littlejohn, the bathroom specialist, in 1991.

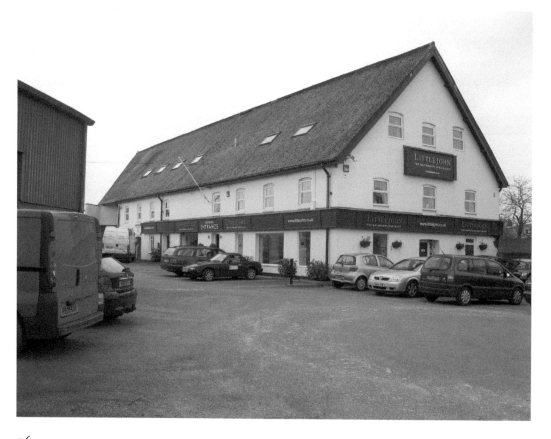

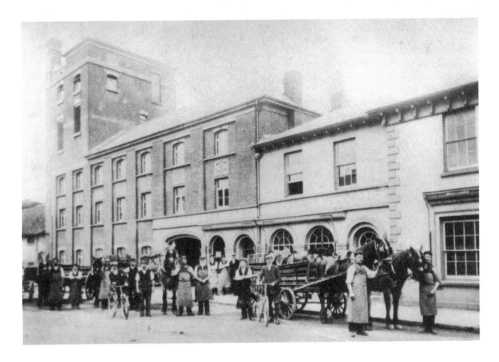

Antrobus Almshouses and Luker's Brewery, 1933

The first almshouse to be built in Petersfield was this one (*inset*) donated by William Antrobus in 1621, intended 'for the relief of poor lone men and women'. However, it struggled to survive financially in the nineteenth century, and the Petersfield family brewing firm of Luker's absorbed the premises into their neighbouring brewery (and tower) site in 1890. The Luker estate eventually comprised the Red Lion, the Market Inn, the Railway Hotel and the Good Intent. In 1934, Luker's sold its business to Strongs of Romsey, which closed the brewery and, a few months later, Petersfield's 'Great Fire' engulfed the building. It was demolished for safety reasons and the whole site was razed to the ground in 1975 to create Tor Way.

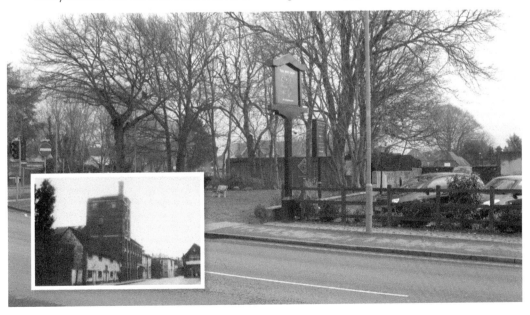

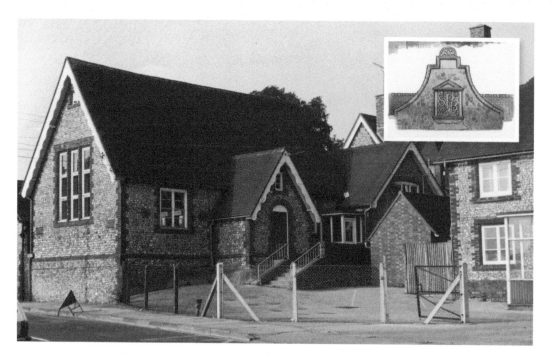

Hylton Road Schools, 1940s

The 1870 Education Act brought in universal compulsory education for all five- to twelve-year-olds for the first time. In Petersfield, the school board built schools for infants, boys and girls in St Peter's Road in 1894 (*inset*), and these buildings served their purpose until 1957 when the secondary school in Cranford Road was opened. The old school remained as a junior school until Herne Junior School was built in Love Lane in 1975. It now houses the infants' school and underwent a major modernisation in 1986. Some of the old school buildings still stand: the school hall became part of St Peter's Court, and the domestic science building a private house.

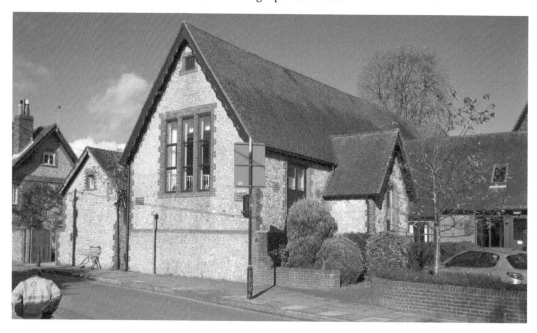

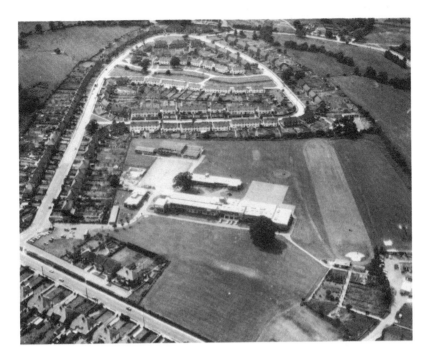

The Petersfield School, 1966

Between 1945 and 1957, the former Petersfield Senior Council School in St Peter's Road was variously referred to as Petersfield County Secondary School or Petersfield Secondary Modern School after the re-designation by the 1944 Education Act. It was not until 1958 that it became the Petersfield County Secondary School, in newly built premises on farmland beside the Causeway. Under the headmastership of Mr E. C. Young, it brought together senior pupils of the old St Peter's Road council schools, girls from the County High School in the High Street and older pupils from surrounding village schools. It became the Petersfield School in the 1990s and currently has approximately 1,200 pupils aged eleven to sixteen. It received Academy status in 2011.

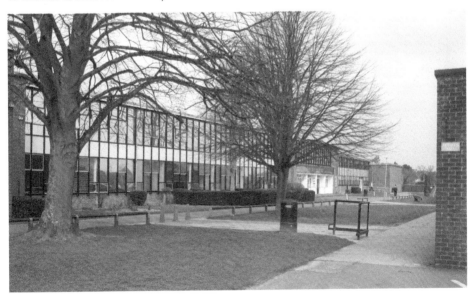

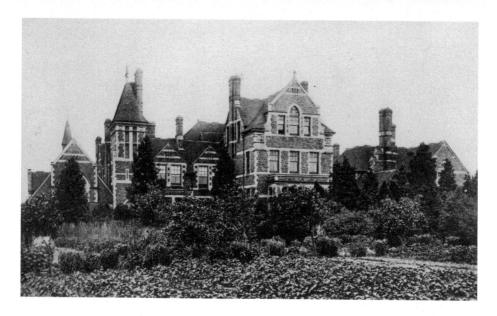

Churcher's College, 1880s

When Churcher's College's 10-acre site on Ramshill first opened in 1881, there were thirty-four boys at the school aged between eight and seventeen, including fifteen boarders, although there was space for three times that number. The land had been donated by Mr William Nicholson of Basing Park, in Privett, a school governor and Petersfield's MP. He had purchased it from Magdalen College, Oxford. During the Second World War, it also housed the pupils evacuated from Emanuel School in Wandsworth. After the war, the school became a voluntary-aided, selective Grammar School, then, in 1979, independent. It became fully co-educational in 1988 and now has over 800 pupils.

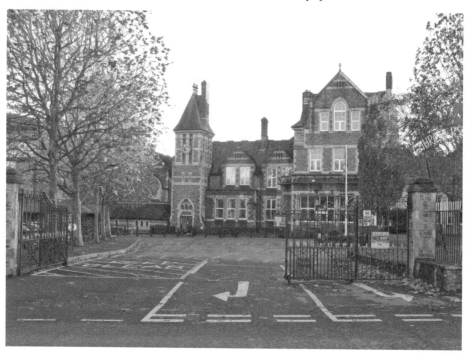

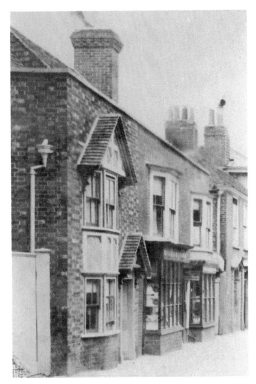

No. 6 High Street

The arrival of Woolworth's (now 99p Stores) next door in 1934 destroyed two-thirds of what had been a fine medieval timber-framed house. Part of the original wattle-and-daub wall can still be seen inside the front door. Over its 400-year history, it has been a private dwelling, a tradesman's house with stabling at the rear, and the property of John Jolliffe, who used it to further his political ends by obtaining more voting rights in the Borough. Two hundred years ago it was a boarding school for young ladies, then an important printer's and bookseller's belonging to businessman Gideon Duplock, who established the town's first library here in 1838. For most of the twentieth century it was a shoe shop.

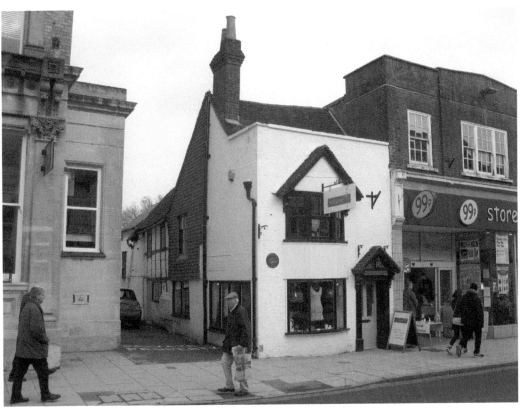

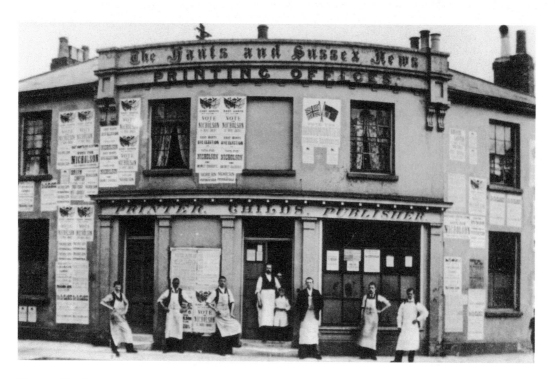

No. 34 High Street, 1897

These premises have undergone a succession of reconstructions as varied as their occupiers. Georgian, Regency and Victorian alterations have given way to a distinctly twentieth-century finish today. A variety of private tradespeople resident in the Victorian era ended with the building becoming Petersfield's first post office from 1878 until 1892. Thereafter, A. W. Childs, the printer, was the tenant and publisher of the *Hants and Sussex News.* From 1900 to 1922 it housed the newly established Petersfield Women's Institute, formed along similar lines to the Men's Institute (*see p. 93*). For about twenty years it was the music studio of Percy Whitehead, then an estate agent's until the start of the twenty-first century. It is now a dental surgery.

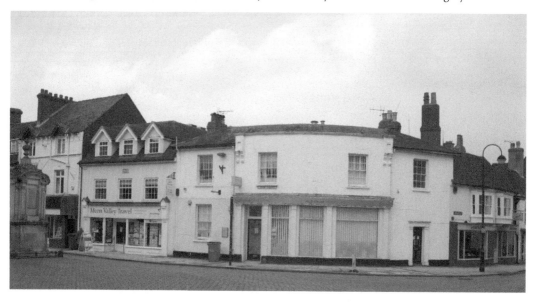

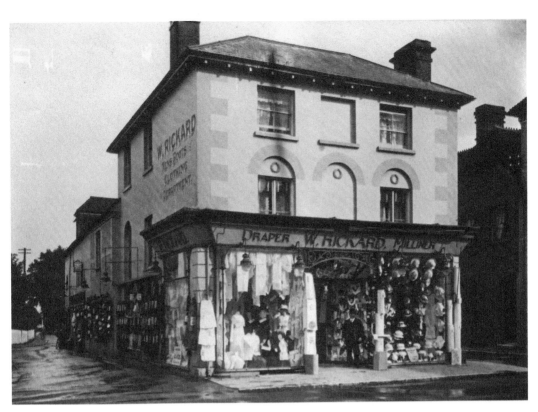

No. 36 High Street, c. 1915

This isolated, early nineteenth-century building is, technically, part of the High Street, because it stands on what was once wasteland at the lower end of the High Street. Speculation suggests that there may even have been a market hall here in medieval times. Most of this side of what is now Dragon Street dates from the seventeenth century, however, indicating that considerable wealth came into the town with the increase in coaching traffic on the London to Portsmouth road. William Rickard's drapery dates from 1911, but the shop has been an estate agent's for several decades. In 2012, the rear of the building was transformed into a rehearsal area for the Petersfield Youth Theatre.

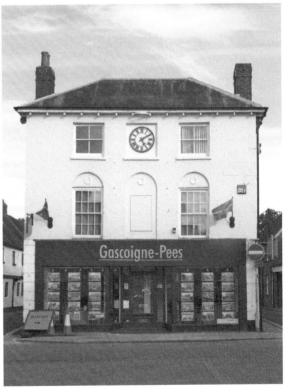

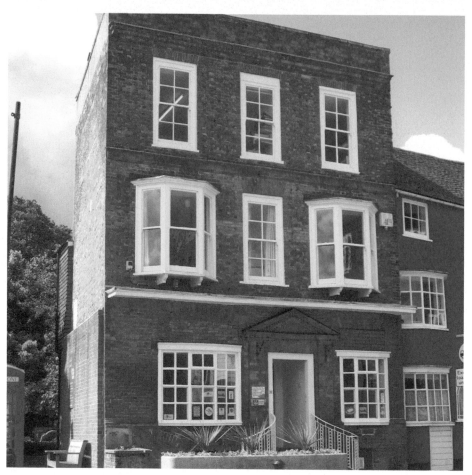

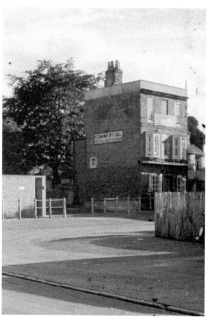

No. 24 the Square, 1930s
One of several properties that belonged to
Magdalen College, Oxford, this building has
had a chequered history. One of the early
eighteenth-century owners was Richard
Churcher, the founder of Chucher's College;
another was John Small, the cricketer. It
became the Commercial Hotel from the 1930s
until the 1950s. It has also housed solicitors,
dentists and a tea shop. The drinking fountain
for the market cattle originally stood in front
of the Coffee Tavern (now the site of the post
office); it was donated by Mrs Money-Coutts
of Stodham Park, wife of the unsuccessful
Liberal candidate for East Hants in the general
election of 1906.

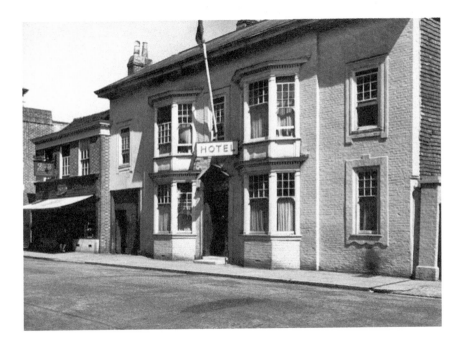

Lyndum House, 1930s.

This eighteenth-century building probably stands on a site originally occupied by a medieval structure. It was leased to a variety of tenants throughout the eighteenth and nineteenth centuries, including several medical practitioners. In the late Victorian period it was seen as an ideal site for Petersfield's town hall, with commodious office space, room for the town library, sufficient garden space for a horse and cart, the town's water cart and possibly even the market. However, the dilatoriness of councillors allowed it to fall into private hands. From 1920 until 1940, it became a hotel with its own garage. Families bombed out of Portsmouth were housed in it during the Second World War, and after the war it reverted to commercial use.

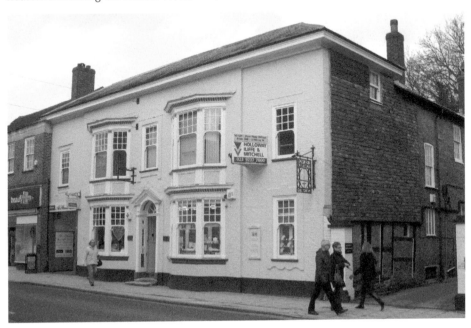

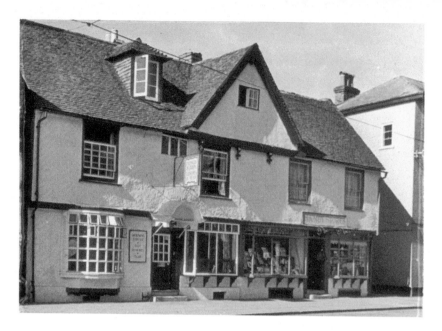

The Punch and Judy, 1960s

This late sixteenth-century timber-framed building contains one Tudor window (above the porch) and two Regency bay windows. In the mid-nineteenth century it became a school for young ladies, one of many in the town, but it had also been the business premises of an ironmonger, a printer, a tailor, and a draper, the last of these being the grandfather of a former speaker of the House of Commons, the Rt Hon. George Thomas. In 1922 the ground floor became a tea room, while the upper floors were rented by the Petersfield artists Flora Twort, Hester Wagstaff and Marie Brahms. From the 1930s until the 1980s, the tea rooms and restaurant were named the Punch and Judy.

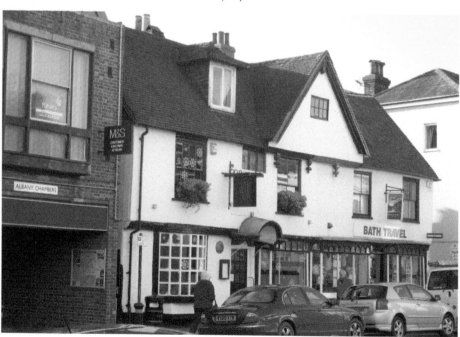

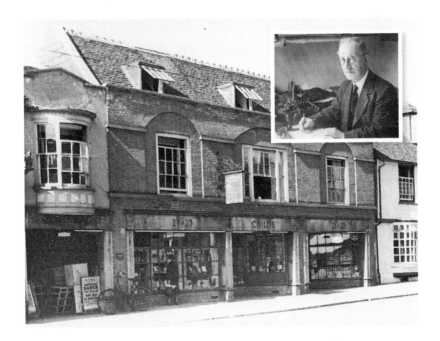

Childs, 1950s

This elegant late eighteenth-century former town house was another victim of the random destruction of High Street properties in the mid-1960s. A. W. Childs' family business – a bookshop with a printer's and bookbinder's at the rear – moved here in 1900. The family enjoyed the oak-panelled rooms, walled garden and conservatory, while the print shop was reached through the passageway on the left with its oriel window above. The local *Hants and Sussex News* (affectionately known as the 'Squeaker') was printed and sold here, and Frank Carpenter (*inset*), its popular reporter and editor and the town's best-known character, worked here for fifty years. For the past fifty years the building has housed supermarkets.

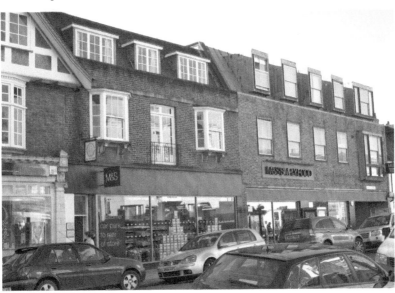

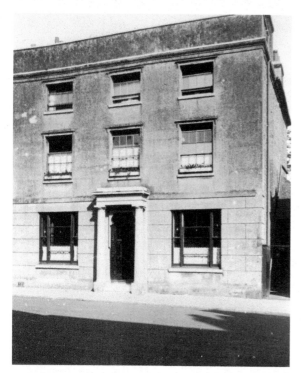

The White Hart Inn, 1920s
Linked by a gatehouse to the adjacent property (now The Rowans Hospice), this building formed part of the late sixteenth-century White Hart Inn, Petersfield's major hostelry, when the town could boast of having roughly 100 beds for guests and stabling for 200 horses. One of the earliest landlords, Thomas Jaques, laid a bowling green in the garden, which attracted Samuel Pepys here in 1661, soon after King Charles II had visited it. It ceased as an inn in 1789 and, after extensive rebuilding, was turned into a private dwelling, the home of various doctors in Victorian times. In 1922 it became the home of Petersfield's Women's Institute and has remained a community centre ever since.

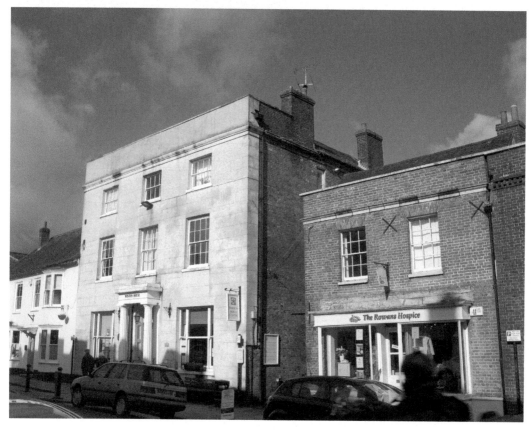

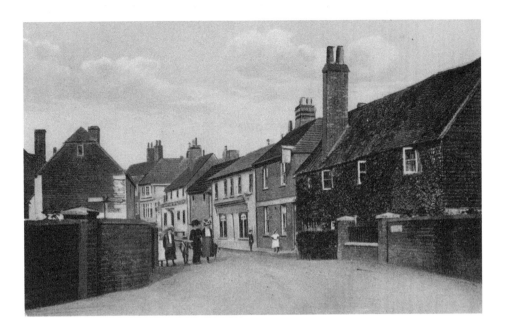

The Forebridge, *c.* 1900

The Forebridge was the name given to the crossroads entry into town between Dragon Street and the Causeway, also once called the Mint. Spanning the South Stream, it resembled more of a bridge in Edwardian times, although the stream still passes under the road today. After the Licensing Act of 1908, the large number of pubs in Petersfield was gradually reduced. Between the wars, a pub near this crossroads, the Fighting Cocks, was demolished as it had become notorious as a lodging house for tramps. The present garage stands where another old pub, the Crown Inn, stood at the corner of Sussex Road (then named Golden Ball Street); it was pulled down in 1961 to improve road traffic conditions.

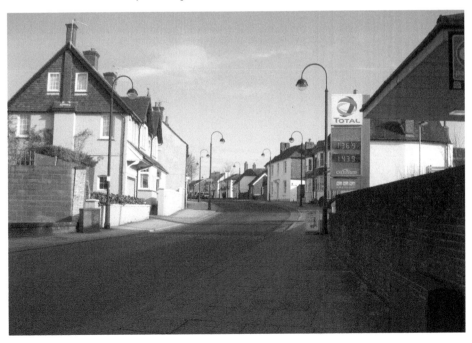

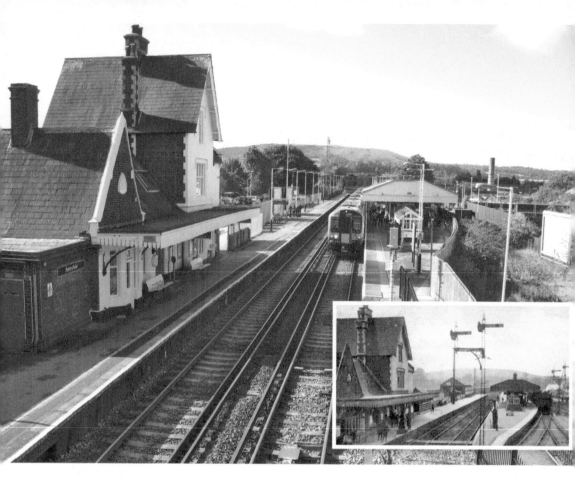

The Railway Station, 1920s

The arrival of the railway through Petersfield (creating the final section of the route from London to Portsmouth) occurred in 1859, bringing a new phase in the development of the town's population, businesses and infrastructure. Six years later, the Petersfield to Midhurst branch line was constructed, extending the network even further afield into Sussex, linking communities along the Rother Valley. Rail excursions to London, Portsmouth and, with ferry connections, to the Continent, were now possible and enjoyed by the wealthiest members of society. The Midhurst link was axed in 1955, depriving the local firms South Eastern Farmers and Itshide Rubber Co. of their private sidings for loading and unloading goods.

The Scout Hut, 1990s

The Petersfield Working Men's Institute had been built thanks to a generous benefaction by Lord Hylton in 1886. It existed to enhance the lives of working men who, having left school at a young age, were lacking both in general education and specific skills for the workplace. When Lord Hylton's estate was broken up and sold in 1911, the building briefly operated as the Petersfield Liberal Club, but was then taken over by the Scouts in 1915 and bought outright by them in 1920. During the Second World War, the Scouts used lorries to collect waste paper and books for salvage, thus contributing to the war effort, and this military-style operation was to continue after the war.

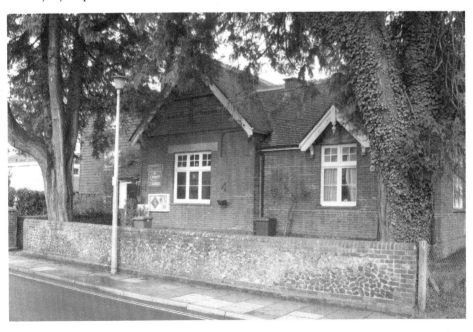

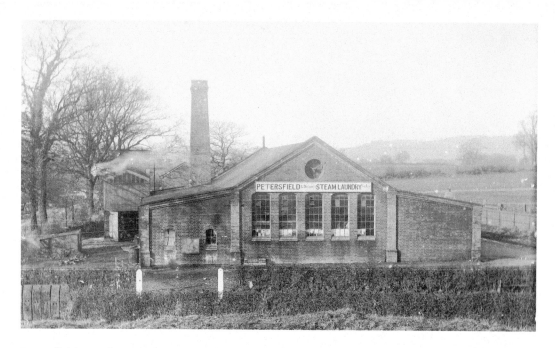

Petersfield Laundry, *c.* 1900

The Petersfield & District Laundry Company, situated in Frenchman's Road, was founded in 1899 and was one of the largest laundries in Hampshire. It was soon regarded as a prosperous industry with the latest technology, around forty employees, and a water supply from its own well. So successful was it that it extended its premises in 1905 to the size it is today. It housed troops in the First World War, saw off competition from an 'electric laundry' in Sandringham Road, merged with the Reliance Laundry of Alton in 1958 when the James family took control, and initiated a subsidiary named Workleen in 1984 for a rental service to local hotels, businesses and factories.

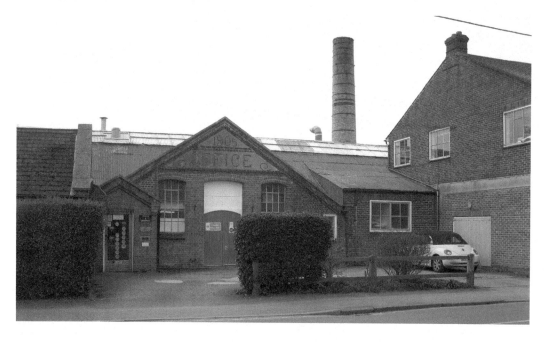

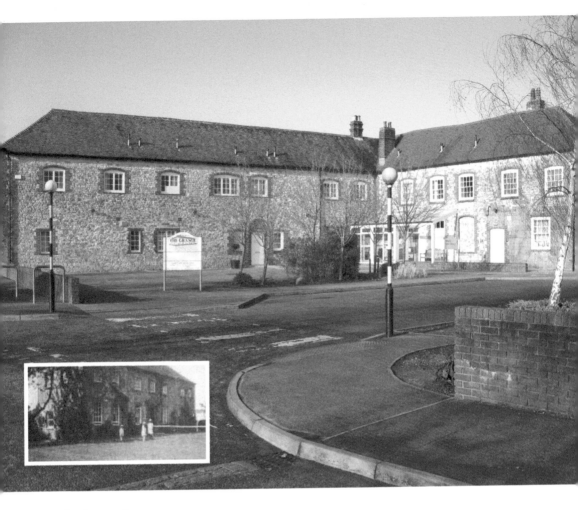

The Grange Surgery, c. 1910

The Grange Surgery is the only remaining building in the town that formed part of Petersfield House, the home of the Jolliffe family in the eighteenth century. Their estate extended from St Peter's Road (by the present police station) down to the present surgery. The land incorporated the Drum Stream, which was exploited to provide the Jolliffes with a series of water features in his extensive grounds. It became a typical estate of the landed gentry on a grand scale. However, after years of conflict with the town's inhabitants, the Jolliffes demolished the main building in St Peter's Road in 1793. The old high coach entrance is visible on the Tesco side of the building.

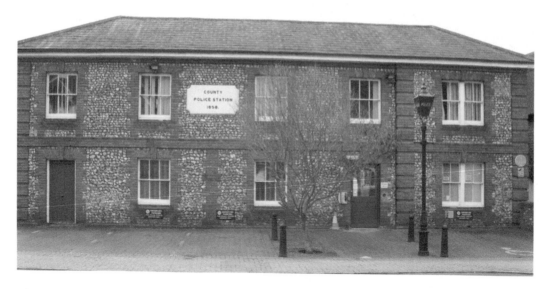

The Police Station

Built in 1858, Petersfield's police station is the second oldest in the county (Romsey being one year older). It was designed by the Hampshire Constabulary's architect, Thomas Stopher (*inset*), and his son, and still includes its original stable block, stable boy's room and water pump in the rear yard. Until the 1930s, the first floor contained accommodation for the superintendant in charge. In the brick-vaulted, stone-floored cellar there remain three original cells with mighty wooden doors and huge locks and bolts. During the Second World War, there were over 100 volunteer special constables operating from this station. However, 2013 will probably see the final departure of the police from this building as (another) county reorganisation takes effect.

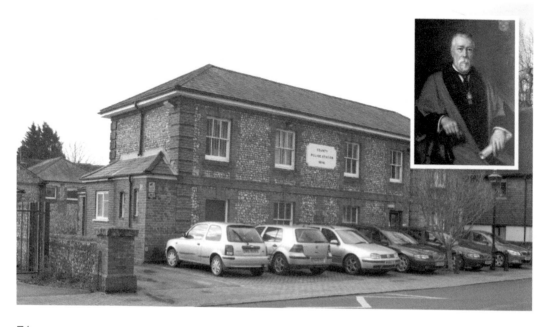

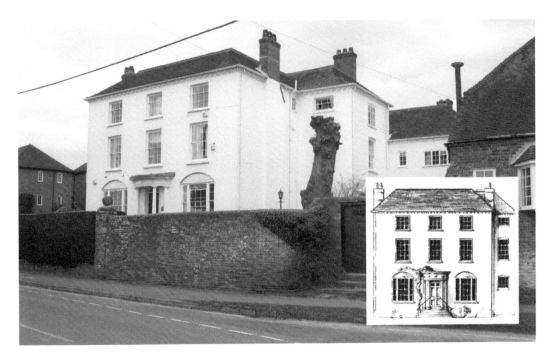

Heath Lodge, 1930s

Known as the Old Vicarage, this Georgian house in Sussex Road was the home of the Vicar of Buriton and Petersfield before the parishes were divided in 1885. Earlier, it was owned and occupied by members of the Jolliffe family, including Sir William Jolliffe, the first Lord Hylton. Canon F. J. Causton, vicar of St Peter's in the late Victorian and Edwardian eras, also lived here. The Jolliffes were probably responsible for adding the porch and curved steps, and three Adam fireplaces and recessed cupboards inside the house. The circular brick structures once seen in the outer wall (*below*) may have been gun emplacements during the Civil War. The lodge was divided into five flats in the 1980s.

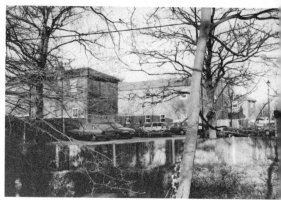

The Union Workhouse, c. 2000

Petersfield's Poor Law Institution, commonly known as the workhouse, was built in Love Lane in 1836, with capacity for over 100 inmates. However, this figure reduced to between fifty and sixty in the Edwardian period, when it offered accommodation and meals to the destitute, the homeless and the workless. A chapel was added in 1899, funded from donations by St Peter's vicar Revd Causton and local residents. The only Petersfield building to be touched – partially – by a bomb in the Second World War, it was taken over by the county council highways department and housed a child welfare clinic after the war. The building was successfully reconstituted as affordable housing in 1997, winning a heritage award for its historically sympathetic design.

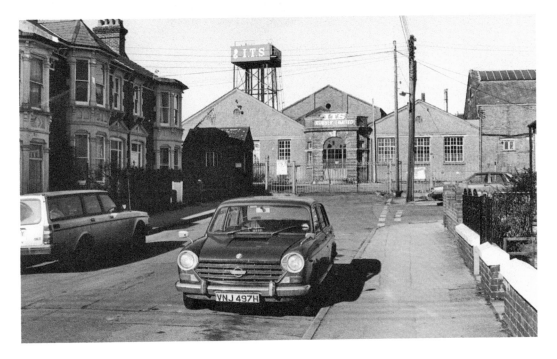

The Itshide Rubber Factory, 1950s

The Itshide Rubber factory was built in Sandringham Road in 1919 by Arnold Levy when he returned to England from America at the end of the First World War. The factory became one of Petersfield's major employers. Between the wars, the company manufactured 'Minibrix' (like a rubber version of Lego), but this gave way in 1942 to the production of items for the Ministry of Supply, such as instrument suspensions and commando boot soles. Fifty years later, the company was producing components for Concorde. Following Levy's death in 1955, Charles Colston, the washing machine manufacturer, acquired a controlling interest in the firm. By the mid-1980s, however, after several lean years of business, Colston's sold the whole site to a developer for housing.

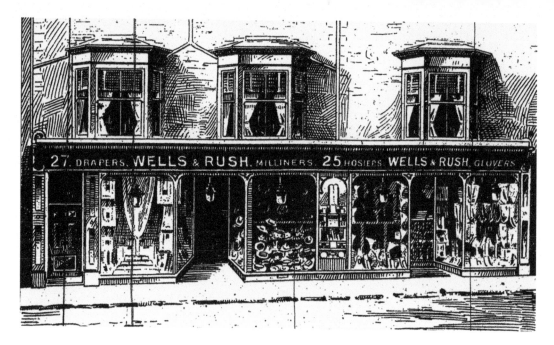

Wells & Rush, 1911

Messrs Wells & Rush, the Chapel Street drapers and milliners, were among the first to advertise their shop, with the above illustration appearing in the local *Hants and Sussex News* in 1911. The shop's name can still be seen on the side wall of the building. This was one of the numerous, independent and high-class specialist establishments that dominated Petersfield's main shopping streets between the wars, before the advent of nationwide chains. In recent times, the double frontage has allowed the premises to be occupied by larger retailers. It became a branch of the stationer's Menzies for many years and now forms part of a chain of Italian restaurants.

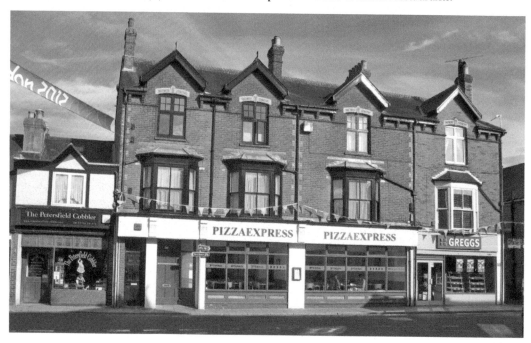

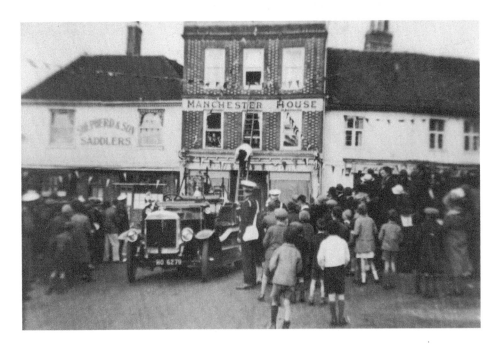

Rowland, Son & Vincent, 1930s

This site, in common with many others in the town, was owned by Magdalen College, Oxford, who leased it to provide them with income. It underwent many alterations until it was finally sold by the college in the early twentieth century. Over the centuries it housed a variety of trades, though from the 1840s it became a draper's shop. Charles Rowland took over the business in 1880 and, with Percy Vincent marrying Beryl Rowland in 1934, the family-run drapery and house furnishings business lasted here for over 120 years, until 2004. The Rowlands bought the neighbouring carriageworks in the Edwardian era and the workshops have now been converted for use by their descendants, who became funeral directors.

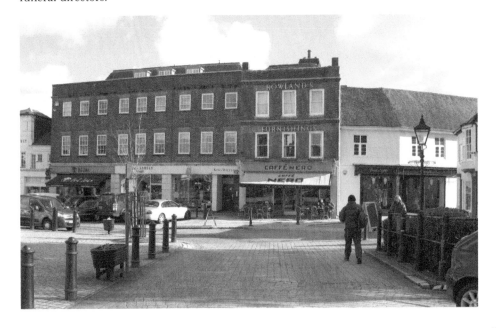

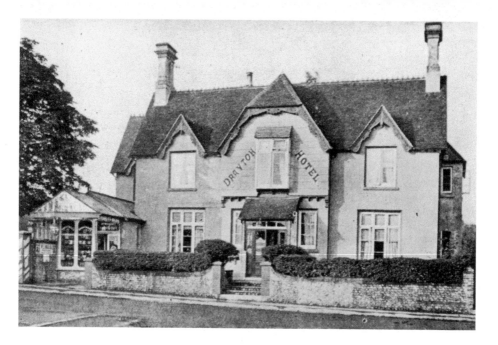

The Drayton Hotel, *c.* 1910

In Edwardian times, the Drayton Hotel advertised itself wittily as a strictly private and commercial establishment, unlike other Petersfield hotels with their bowling greens, fine wines or temperance nuances. It offered plain and simple accommodation with a tea room and meeting room for local societies. In 1927, it was turned into the offices and laboratory of South Eastern Farmers Ltd, which it remained for almost forty years, serving the wholesale dairy and milk processing and bottling plant developed behind it, receiving milk churns daily from local dairy farmers, and with access to its own railway siding. It was completely transformed again in 2010 and now houses the UK offices of the international company Commodity Appointments Ltd.

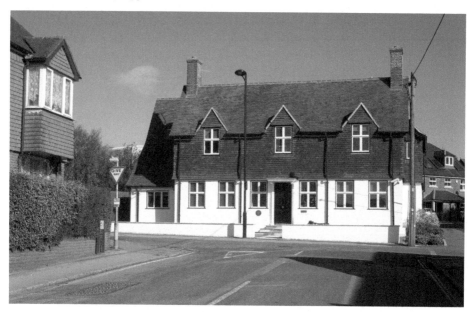

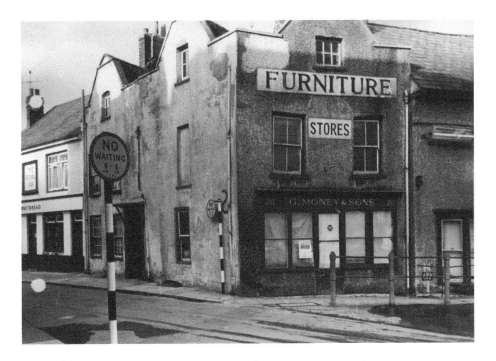

Petersfield Library, 1970

The south-west corner building in the Square, probably dating from the seventeenth century and showing a Dutch influence in its gabling, was occupied by private owners until the Victorian era, when a variety of tradespeople began to move into the Square. During the First World War, a Scottish regiment billeted in the town used it as their orderly room and guard room. By 1923, George Money had moved his watchmaking business there, followed by his furniture shop, and he remained there until after the Second World War. The whole corner plot was demolished in 1970 and it remained vacant until the new town library was constructed here in 1981, its fourth – and final – move in fifty years.

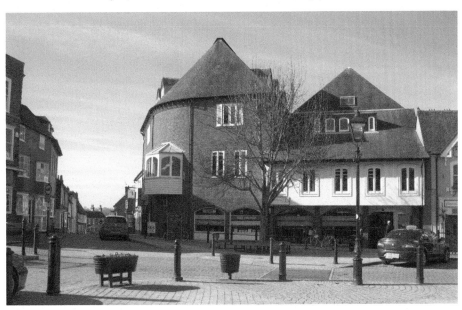

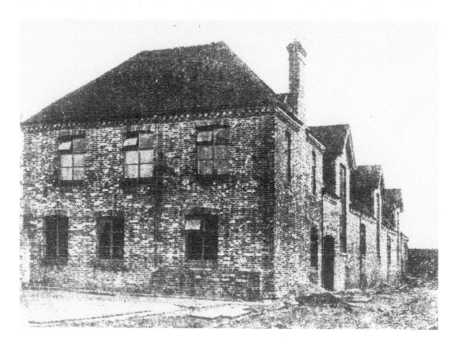

The Drill Hall, 1899

The new drill hall of the I Company 3rd Volunteer Brigade of the Hampshire Regiment in Dragon Street was opened in January 1899. It was a conversion of the old brewery malthouse on the site, which had belonged to the Chichester brewing family of Henty's in the early Victorian period. Inside, the upper floor was removed and a new roof constructed, while outside, space was allocated for a parade ground. The hall was soon to serve as the premier venue in the town for many types of public event, including exhibitions, concerts and sports tournaments, and from 1911 until 1935 it served as the major concert hall for the Petersfield Musical Festival.

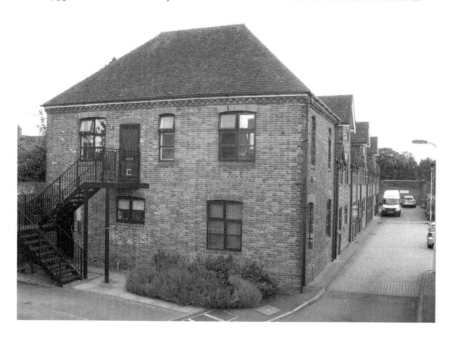

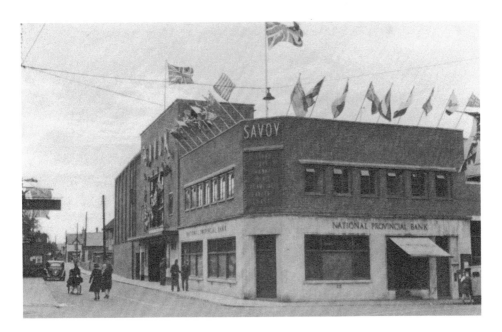

The Savoy cinema, 1950s

Silent films had been shown in the town at the 395-seat Electric Theatre (now the site of the Nationwide Building Society), but in 1921 local businessman Hyman Filer accepted the Electric as payment by a customer for a debt! In 1935, he built the 700-seat Savoy cinema next door along Swan Street. Before The Second World War, film programmes finished at 9.55 p.m. to allow cinema-goers to get to the pubs before closing time. However, with the advent of the television and video age, Petersfield people gradually preferred to go to the larger cinemas in Guildford or Portsmouth, and the Savoy closed in 1985. It became a bingo hall, a cabaret theatre and, after a few years' closure, the Vertigo nightclub. The building was demolished and the site transformed into a block of flats in 2012.

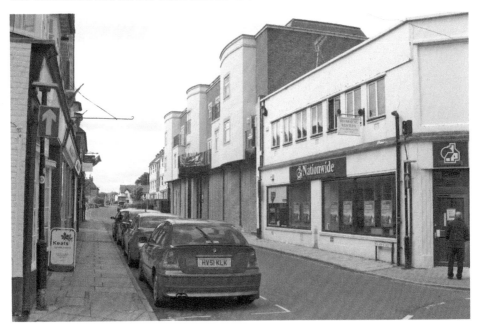

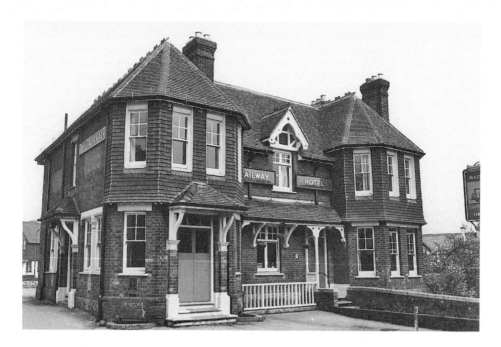

The Railway Hotel, 1950s

The Railway Hotel, built in the same decade as the railway came to the town, witnessed a tragic incident in 1906. An armed 'mad sailor' passed through the town and shot a lady who was going with her young daughter to the stables behind the building. She later died of her wounds. The man was convicted of murder, pronounced guilty but insane and committed to an asylum. In the 1950s, the hotel was licensed, offered accommodation and a large car park, and catered for parties. However, by the 1980s business was poor, and the owner, Whitbread, decided to sell it. It was finally demolished in 1985. The warden-supervised Lavant Court, comprising forty-two flats, was built in its place.

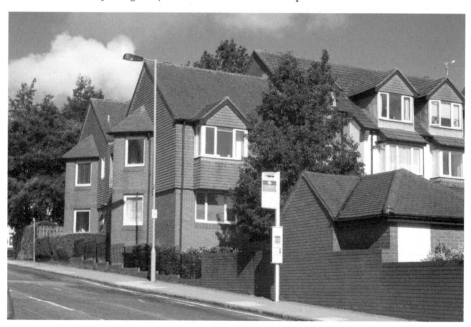

The Cottage Hospital, 1898

Built by public subscription in 1871, Petersfield's cottage hospital housed thirty-seven patients in its first year, rising to eighty-seven by 1896. In the Edwardian era a new operating theatre was funded by John Bonham-Carter and a new Edward VII wing by Sir Heath Harrison. With the advent of the NHS in 1948, the hospital was managed by the Portsmouth & South East Hampshire Health Authority. In the 1980s, the old cottage hospital building could not be saved for the community because the Authority was obliged to sell the site to the highest bidder. A new community hospital was completed in 1991, and the old hospital was finally demolished in 1996, to be replaced by the headquarters of the Drum Housing Association.

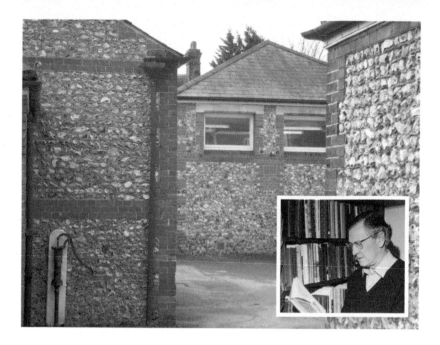

Petersfield Magistrates' Court, 1893

A 'Petty Sessional Court House', conveniently situated behind the police station, was built in 1893, consisting of the courtroom and accommodation for the justices, clerks, police, witnesses, press and public. It was a thoroughly modern building for its time, with an efficient heating system and hot water supply. It remained a courthouse until 1995. In the 1990s, a group of enthusiasts from the Petersfield Area Historical Society actively began the search for a potential site for a town museum. Thanks largely to the energies of Wilf Burnham and the support of many organisations in the town, and with a generous legacy from Freddie Standfield of East Meon (*inset*), the courthouse dream was realised; it opened in 1999.

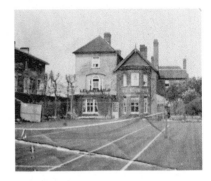

Worcester House, 1890s

Situated at the corner of Heath Road and Dragon Street, this seventeenth-century house was built by Stephen Worlidge, on what was then a corner of the High Street. It remained in the family for three generations, all of whose heads were mayors of Petersfield. The most famous of them was John Worlidge, the experimental botanist and agricultural writer. He added a garden to the property, and it was here that he experimented with husbandry and gardening and wrote two treatises on the subjects. He also specialised in beekeeping and cider-making and devised a seed drill for use by farmers. He is buried in St Peter's church.

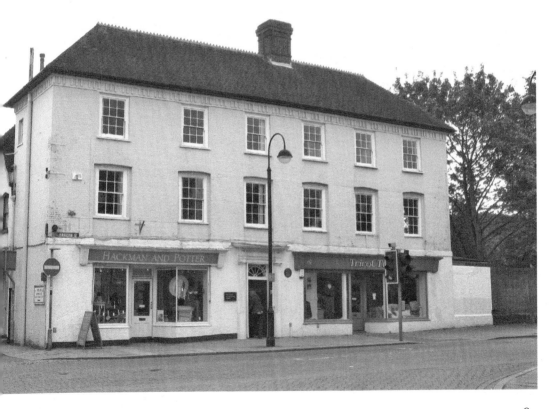

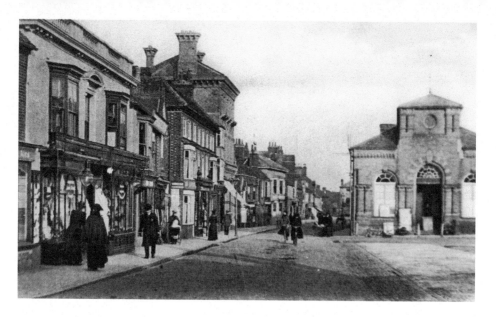

The Corn Exchange, *c.* 1905

The old corn exchange, dating from 1866, replaced four houses on the site. Its Italian style complemented that of the bank (*above left*) in the High Street. It consisted of a large open hall stretching down the High Street (hence Rowswell's address as No. 1) but was used only once fortnightly for the sale of corn. More practically, it became the town's prime venue for concerts and plays, social gatherings and formal dinners, housed the county court, served as a church hall for St Peter's, replaced the church itself when St Peter's was being reordered, was a headquarters of the Hampshire Regiment, and even hosted a circus. It was converted into shops and gained its upper storey in the 1930s.

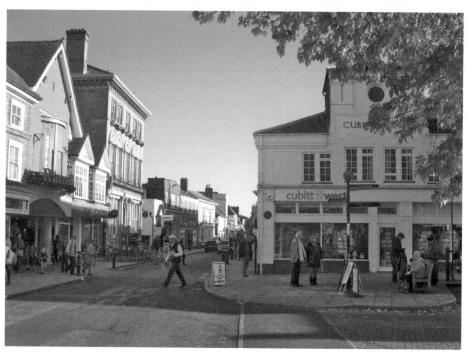

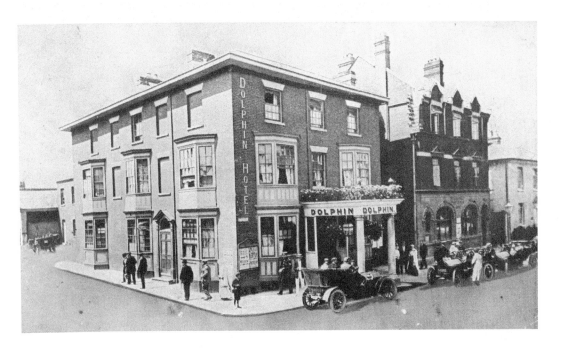

The Dolphin Hotel, 1910s

The Dolphin Hotel was one of the four major inns in Petersfield High Street in the great coaching era of the eighteenth and early nineteenth centuries. The 'Rocket', a four-horse coach, transported passengers from the hotel to Godalming station for the London train. The hotel's portico stretched as far as the carriageway to allow guests to alight from their coaches – and later their cars – under cover. William Cobbett stayed here in 1825, commending the stabling facilities. After the First World War, the premises became the Petersfield Girls' County High School, which remained here for over forty years. In 1965, the building and two adjacent properties were demolished by the Raglan Development Trust and replaced with Dolphin Court.

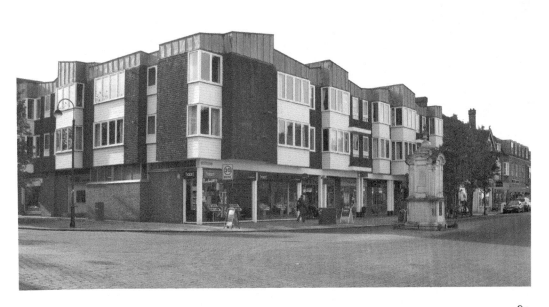

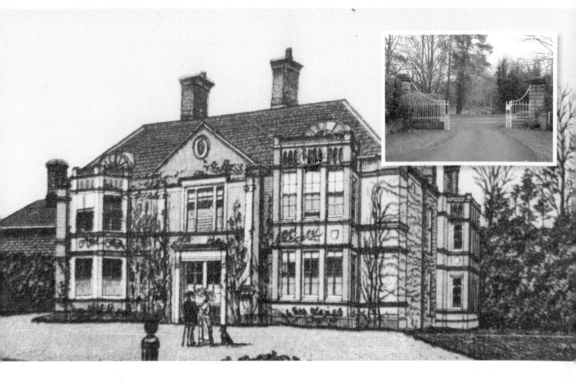

Heath House, 1940s

This residence in Sussex Road, dating from the sixteenth century, belonged to the Matthews family. They were suspected of offering shelter to 'priests of Rome' at a time when this was considered treason, and there was a 'priest's hole' under the floorboards. The last occupiers were the Russell family, commemorated in nearby Russell Way. During the Second World War it was a sanatorium for sick evacuees. It became derelict after the war and was pulled down in 1956. Some of the original outbuildings still stand (*below*), together with the railings, entrance pillars and gateway chains.

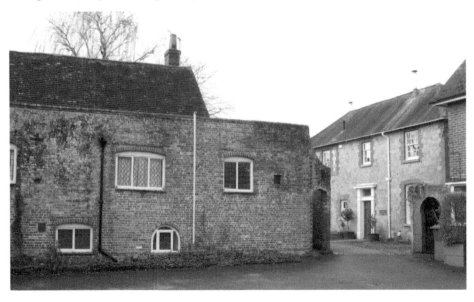

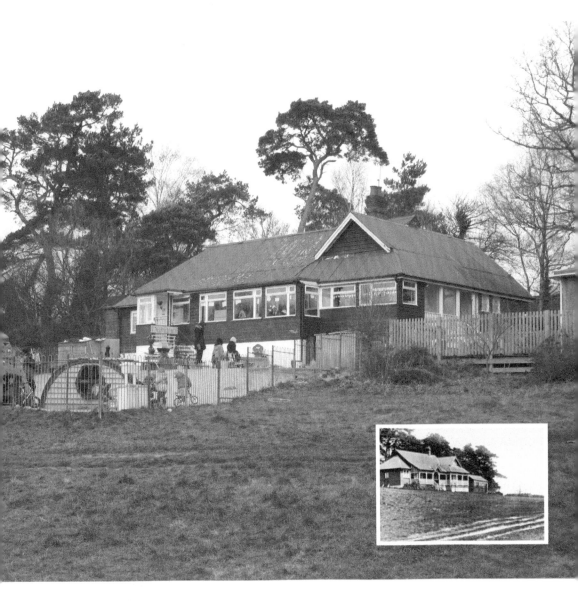

The Golf Clubhouse, 1950s

Golf began on the Heath in the 1890s when this clubhouse was built. Despite the Heath being owned by Lord Hylton, he did allow golfers free and undisturbed access to their course. This was extended in the 1970s by the purchase of extra land on the other side of Sussex Road. The golfers, numbering around 400 men and women, vacated the Heath altogether in 1997 and moved their course to Liss; their former fairways and greens reverted to natural habitat for wildlife. The Heath has since restricted its sporting activities to cricket, fishing and boating, and the old clubhouse has been transformed into a nursery school.

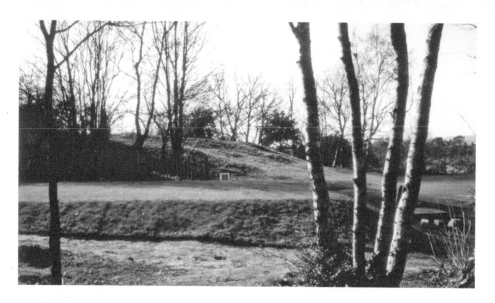

The Heath Barrows, 2300–1400 BC

During the Bronze Age and Iron Age, the Heath was occupied by tribes for agriculture and cattle-rearing, as it provided nutritious gorse for animals in winter. This was also a convenient place to erect clan memorials, usually constructed of soils and turfs, which survive as a barrow cemetery today. The twenty-one areas scheduled as *tumuli* form an unusually large cemetery in a low-lying area; they contain four different types of barrows, most dating from the Iron Age. Mesolithic flints, arrowheads and flakes were discovered when turf was relaid for the golf course in the Edwardian era. Although some barrows are to be excavated in 2013, it is unlikely that human remains survive, because of the acidic nature of the soil.

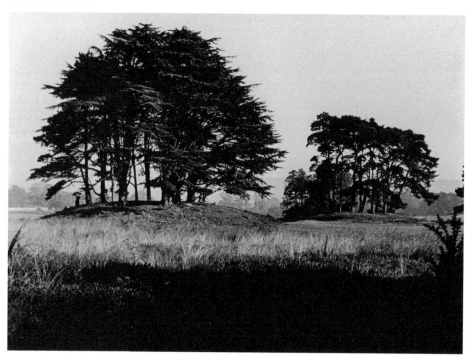

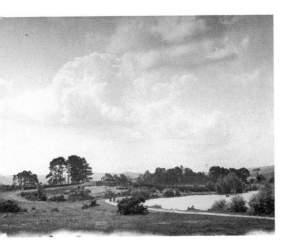
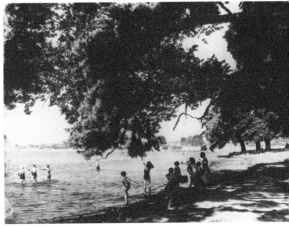

The Heath Pond, 1930s

Petersfield's 'jewel in the crown', the Heath and its pond have long enabled every resident to enjoy their natural beauty and rural ambience without straying far from the town centre. Now managed jointly by the town council and the Friends of Petersfield Heath, the area has always been exploited for its open space (hosting the taro fair each October); its sports facilities (cricket and fishing); its recreational facilities (children's play areas, boating, kiosk); and its millennium path for disabled access. In the past there have been swimming facilities, musical concerts, a golf course, itinerant fairs and even military exercises here. The greatest change from the past, however, is the – now ubiquitous – vegetation covering all sides of the Heath.

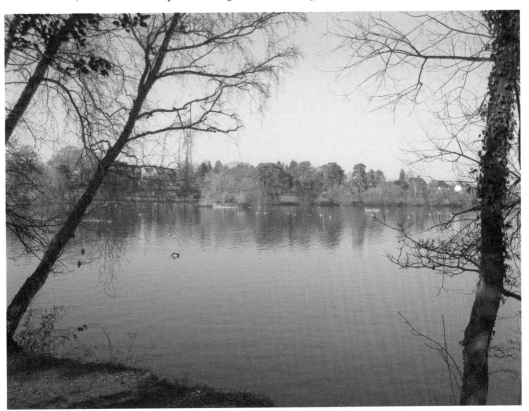

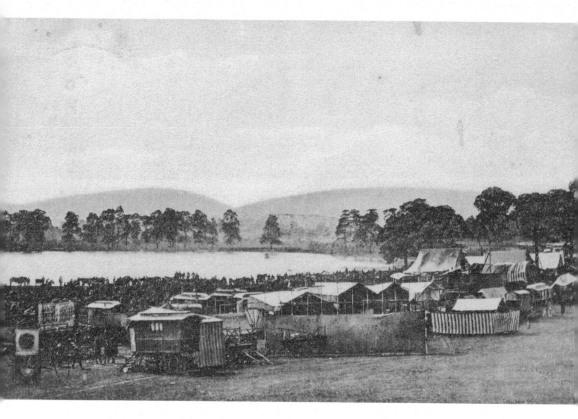

The Taro Fair, 1930s

The taro fair, believed to have been granted to the Lord of the Manor as long ago as the reign of Henry III in the thirteenth century and always held on the Heath on 6 October, consisted of a horse fair in the morning and a pleasure fair in the afternoon and evening. 'Useful carthorses and colts', working animals used by all farms in the Edwardian era, were auctioned, as well as 'all classes of store sheep, beats and horses'. Later in the day, crowds enjoyed a large number of 'catchpenny attractions: shooting galleries, refreshment booths, coconut shies, knock-'em- downs, swing boats and illuminated steam roundabouts'. The last sale of horses took place in 1953.

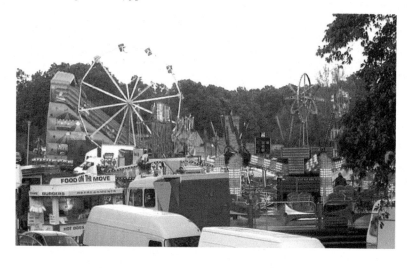

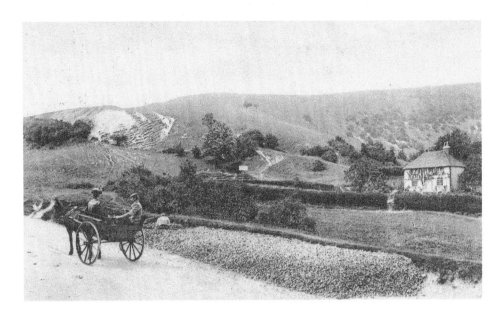

Butser Hill, *c.* 1900

With its steep incline and narrow roadway, Butser Hill, the highest point of the South Downs at 888 feet, presented a problem for both pedestrians and horse-drawn coach traffic in the early Victorian era. The idea of excavating a passage in the hillside was first mooted in the 1820s by the Trustees of the Portsmouth & Sheet Bridge Turnpike Road. The work took three years from 1828; Butser was 'lowered' by 60 feet and the road realigned and widened to 30 feet. Just five years later, a further 10 feet in depth were excavated. More excavation and an improvement – especially for the new motor cars – came at the end of the nineteenth century.

Acknowledgements

The author wishes to thank the following for their contributions towards this photographic record of Petersfield: David Allen, Pat Randall, Edward Roberts, Graham Brown, Vincent Edberg, Robin Baumber, Neil Pafford, teresa Murley, Joe Flux, The Petersfield Society, Petersfield Library and Petersfield Museum.

The following works have been consulted in writing the text:

Brooks and Clarke, *The History of Churcher's College*, (2007).

Bullen, Crook, Hubbuck and Pevsner, *The Buildings of England: Hampshire* (2010).

Jeffery, *Petersfield at War* (2004).

Jeffery, *Post-war Petersfield* (2006).

Jeffery, *Petersfield a Hundred Years Ago* (2012).

Petersfield Area Historical Society (PAHS), *High Street, Petersfield* (1984).

PAHS, *A History of Christianity in Petersfield* (2001).

PAHS, *Petersfield Place Names* (2000).

Ray, Gard & Walker, *The Market Square, Petersfield* (2008).

In addition to these sources, the biannual PAHS Bulletin contains many articles whose contents have been quoted for their historical authenticity. The author expresses his gratitude to all those whose research had yielded important and interesting information for this volume.